Historic
BAY AREA
VISIONARIES

To Carol whos love of history reflects her loving nature.

Always.

Eleanor

Historic

BAY AREA
VISIONARIES

ROBIN CHAPMAN

THE
History
PRESS

Published by The History Press
Charleston, SC
www.historypress.com

Front cover, left to right: Robert Louis Stevenson on his Pacific travels. *Courtesy of the City of Edinburgh Council–Libraries*; Sarah Winchester as a young woman in San Francisco. *Courtesy of History San Jose*; Charlie Chaplin as the Little Tramp. *Author's collection.*
Back cover: Juana Briones's grave in Menlo Park, California, and a vintage postcard from the author's collection of San Jose, featuring the Electric Light Tower, which brought the first electric lights to California in 1881.

First published 2018

Manufactured in the United States

ISBN 9781467139069

Library of Congress Control Number: 2018945784

Notice: The information in this book is true and complete to the best of our knowledge. It is offered without guarantee on the part of the author or The History Press. The author and The History Press disclaim all liability in connection with the use of this book.

For my family, with grateful thanks.

Contents

Introduction: Redwoods, Soil, Ocean and Bay 9

1. Lope Inigo: The Vision to Survive Disruption 15
2. Juana Briones: The Vision of Compassion 37
3. Robert Louis Stevenson: The Vision of Adventure 55
4. Sarah Winchester: The Vision to be Different 73
5. Thomas Foon Chew: The Vision of the Entrepreneur 91
6. Charlie Chaplin: The Vision of Artistic Innovation 109
7. On the Trail of the California Visionaries 127

Acknowledgements 145
Notes 147
Selected Bibliography 157
Index 163
About the Author 173

REDWOODS, SOIL, OCEAN AND BAY

Driving up into the Santa Cruz Mountains from the Santa Clara Valley to Skyline Boulevard can be a journey of sensory delight. There is more open space, green space and pasture. The scent of the woodland is on the breeze. On a sunny day, as you head up from the valley that nuzzles the shoreline below, it can be ten degrees cooler on Skyline, turning the weather in winter from mild to chilly and in summer from hot to temperate. Still, temperatures rarely get too hot or too cold in this region. The Santa Cruz Mountains act as a buffer between the wild Pacific Ocean and the mild bayside, guarding the weather from extremes.

The surrounding hillsides were once covered with old-growth redwoods nurtured by the Pacific fogs that slip over the mountain crest at dawn and dusk. Among the largest and oldest living trees in the world, redwoods provide durable lumber for construction, and the trees along these roads were among the first natural assets Americans harvested—almost—into oblivion after the Gold Rush. At the south end of Skyline, there is a remaining stand of ancient redwoods at Big Basin Redwoods State Park. Founded in 1902, this park shows how California often mitigates its visions of enterprise with the spirit of preservation.

It was the Gold Rush that brought immigrants to this part of the state in large numbers, though the region had quietly nurtured its own visionaries long before that. Today, the modern road rises from sea level to 3,000 feet at ridge top in just 6.3 miles. Pines and new-growth redwoods reach their arms to the sky and bathe the road in dark green shade. At dusk, wild creatures

Big Basin, California's first state park, was established in 1902 to protect a stand of ancient redwoods in the mountains above the Santa Clara Valley. Harvesting redwood trees created wealth. Preserving them was a big idea. This 1901 photo is by conservationist A.P Hill. *Courtesy of History San Jose.*

appear and reclaim their territories. Sports cars, motorcycles and bicycles retreat and make way for deer, fox, bobcat, coyote, possum and cougar.

Moving up from the modern valley, you may get the feeling you are moving back in time. Evidence of the ancient people who walked here can still be found in the surrounding woods. Early Spanish explorers encountered them as they crossed these mountains, pausing along the crest for their first glimpse of San Francisco Bay. Americans who settled here gave nearby villages evocative names like Redwood City, Mountain View and Woodside for their proximity to this wild beauty.

Just a few miles south along Skyline Boulevard—also known as California State Route 35—there are several vista points at the Windy Hill Open Space Preserve. Pull over and you will find yourself in one of the very few places in the region where you can see both the Pacific Ocean and San Francisco Bay stretched out beneath you on either side of the road. Look carefully at the valley tableau and you can spy Hoover Tower at Stanford University in the center of your view. The technology revolution began on the tree-lined streets near Hoover. Then, look south for the tall buildings of urbanized San Jose,[1] long ago the first civilian settlement in Spanish California. To the north, if the fog has not crept across the Golden Gate, you can see the outlines of San Francisco. Founded by fortune seekers, tested by earthquake and fire, it is a city changed repeatedly by a rush for gold that continues to this day.

The view explains a great deal about why innovators thrived here. The region's geography kept it isolated until its most recent history, and solutions had to come from within—since they could not come any other way. The richness of the land supported the lives of its people. The location of the bay and its great size created a commercial hub for its pioneers. The creeks along these ridges brought water to its aquifer and loam to its soil, creating some of the world's best conditions for agriculture. Beginning in the nineteenth century, world-class universities and colleges—at Stanford, Santa Clara and San Jose to name the homes of just three—enriched its intellectual life and educated its people. The Pacific Ocean served as the region's most important thoroughfare long before the railroad and two centuries before the interstate freeway.

There are several repeating threads that weave through its stories. The early missions created the first big disruption, established the Spanish on this frontier, and were headquartered on the nearby Monterey Peninsula. The arrival of the first transcontinental railroad speeded commerce and opened Northern California to the world before there was even a rail station in

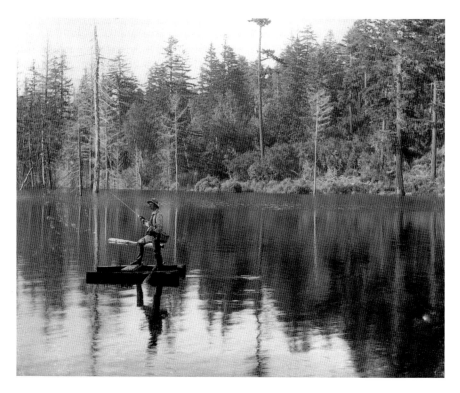

The mixture of urban and rural has long been one of the most attractive features of the land that became Silicon Valley. This early twentieth-century photo shows a spot in the Santa Cruz Mountains just a few miles from downtown San Jose. *Courtesy of History San Jose.*

sleepy Los Angeles. The orchards, first established in the Santa Clara Valley by the Franciscans, also tie past to present. There were those who planted the first seedlings, those who labored among their rows, those who turned them into profit and those who found inspiration in their beauty.

The sweep below Skyline that stretches all the way from San Francisco to Monterey is the setting for the tales that follow. They give us glimpses into the lives of just a few of the many people whose vision helped California become the giant it is today. Much was lost and much was gained as people in this region struggled to understand one another, find a balance between development and exploitation and tie California to the rest of the continent and the rest of the world.

An Ohlone man insists on being treated with respect as his people vanish around him. A multicultural woman builds a fortune in cattle and property and takes time to care for others. A poet finds adventure and a way to inspire

change. An independent widow creates a home so unique, millions come to see it long after she is gone. An immigrant from China prospers against all odds. A child of Victorian poverty finds artistic freedom and joins in the founding of an international industry.

Lope Inigo, Juana Briones, Robert Louis Stevenson, Sarah Winchester, Thomas Foon Chew and Charlie Chaplin—all touched California in powerful ways and were touched by its unique ability to inspire creativity and incubate new ideas.

Look down at the valley and across to the Pacific. This is the land that nurtured the stories that follow.

When the Spanish first encountered the people of the region, many of the interactions were recorded in diaries and journals still available to us today. Franciscan Pedro Font wrote from Palo Alto in March 1776: "As soon as we halted, thirty-eight Indians came to us unarmed, peaceful, and very happy to see us…[T]hey go naked like all the rest." Later, from another spot along the bay, he wrote: "We were welcomed by the Indians in their village, whom I estimated at some four hundred persons, with singular demonstrations of joy, singing, and dancing."[4] The Spanish noted many of the villages seemed related by shared customs and languages. The newcomers called the natives *Costaños*, or "people of the coast," a Spanish name that evolved in English to Costanoan.[5]

Cultural anthropologist A.L. Kroeber of Berkeley, who befriended and studied Ishi, one of the last of the independent Yahi in California, used the name Costanoan in the early twentieth century to identify these California coastal Indians in his groundbreaking *Handbook of the Indians of California*, the first scholarly book on California's original residents. Linguist Richard Levy, later in the twentieth century, identified eight Costanoan dialects, from Karkin in Contra Costa County to Ramaytush in San Mateo, Awaswas in Santa Cruz and Rumsien near Carmel. Tamien—sometimes spelled Thamien or Tamyen—is identified as the indigenous language of the Santa Clara Valley. Priests at Mission Santa Clara de Asís were the first to record the word when Antonio Murguía and Tomás de la Peña wrote to Father Junípero Serra from Mission Santa Clara that the "place of the mission is called Thamien in the language of the natives."[6]

These Tamien-speaking people of the coast were Lope Inigo's people.

The name Ohlone has come into use in recent years to replace Costanoan. The origins of this name are obscure. But the word is indigenous and has a sound both "sweet and strong," to paraphrase Felipe Arroyo de la Cuesta, a Franciscan who studied California Indian languages in the early mission period. Descendants prefer Ohlone to Costanoan, a name of Spanish and Anglo-American origin.[7]

The Tamien Ohlone were Lope Inigo's ancestors.

His records had long been gathering dust in the archives of Mission Santa Clara and the Pueblo of San Jose, both established in Ohlone territory in 1777, when an issue related to twentieth-century transportation created an opportunity to bring them to light. In the 1990s, the Santa Clara County Transportation Agency—now called the Valley Transportation Authority (VTA)—planned a light-rail extension to run through a Mountain View–Sunnyvale area called the Inigo Mounds, a

Louis (sometimes identified as Ludwig) Choris was one of the few artists to document the lives of the indigenous people of the San Francisco Bay Area while a few were still living in their traditional way. *Bateau du Port de San Francisco* shows Ohlone on the bay in 1815. *Courtesy of the Bancroft Library, University of California–Berkeley.*

prehistoric archaeological site adjacent to Moffett Field. Oral tradition and records from the Spanish and Mexican eras said the mounds marked Inigo's ancestral village as well as the place he was buried.

The site was eligible for listing in the National Register of Historic Places, so state and federal law required what is known as mitigation. The compromise was to commission a series of scholarly papers telling Lope Inigo's story and the story of the Tamien Ohlone. The county hired historians Laurence H. Shoup, Randall T. Milliken and Alan K. Brown, along with several Ohlone descendants, to complete the reports, which were presented to the county in May 1995. Slightly more than a century after Lope Inigo's death, these works, said the project's manager, "provoke much thought about the ways in which cultures clash and intermingle, and in which survivors, in the face of all odds, adapt to change."[8]

The research also produced something unique in California history—the biography of an individual California Indian—one of the very few ever written. It was certainly the only one ever drafted for a light-rail line with the help of California tax dollars. Though Lope Inigo's name had long been known, most of the details of his life come to us as a result of this project.

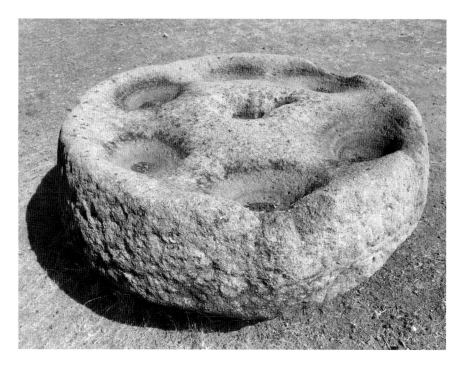

For thousands of years, acorns were a staple of the Ohlone diet. They were finely ground by women working together. Grinding stones were common tools in Lope Inigo's world. *Photo by the author.*

His father's Ohlone name was Samis, and his mother was called Temnem. They were born in the 1750s and thus were young adults when the Spanish came to the Santa Clara Valley in the years after 1769. Protected by deserts to the south, the Sierras to the east and the Pacific to the west, California and its indigenous people had been isolated for thousands of years. Samis and Temnem would have understood encounters like one recorded by Pedro Font with an Ohlone near what became San Mateo: "As soon as he saw us, he manifested the greatest possible fright that it is possible to describe. He could do nothing but throw himself full length on the ground, hiding himself in the grass in order that we might not see him, raising his head only enough to peep at us with one eye."[9]

We identify the strangers who rode into California then as Spanish, but that name, like Ohlone, is not an exact one. It is true they were the cultural heirs of the Spanish soldiers who had conquered the Aztecs in Mexico in 1521. Yet after two and a half centuries in Mexico, only some of them now came from Spain. The majority represented a new American

amalgam. By the eighteenth century, though citizens of a Spanish colony, they were a modern mixture of African, Anglo, Portuguese, Italian, Arab, Aztec and Southwestern Indian—and probably other cultures, as well. What they had in common was the king of Spain, to whom they pledged their allegiance; the Church of Rome, to which they entrusted their souls; and the Spanish language, in which they conducted their business. Once they came to California, they would call Mexico "New Spain" for just fifty years more before they tossed aside Spanish rule for Mexican independence. Soon afterward, Mexican rule would itself be supplanted in California by American statehood.

Lope Inigo was born in 1781, four years after the founding of Mission Santa Clara, in the year Father Junípero Serra laid the cornerstone of a new mission church. "The construction of this new church over the following three years must have been an amazing thing for the local native people, for its size was impressive for its time and place."[10] Inigo's family came from a village about six miles north of the mission, which the priests called San Bernardino, near present-day Mountain View. By the time Inigo was eight, his mother had died and his father had taken a new wife called Giguam. In June 1789, Giguam gave birth to a daughter, and on July 13, 1789, the family came to Mission Santa Clara, where the baby was baptized with the name Justa.

A few months later, on the day after Christmas, Samis and Giguam presented their eight-year-old son for baptism. Though the mission archives do not record his Ohlone name, he was christened Inigo, a name taken from Saint Ignatius, the Bishop of Antioch, a first-century Christian martyr. His

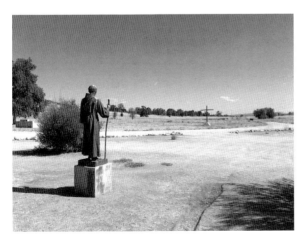

Father Junípero Serra walked from his headquarters near Monterey to lay the cornerstone of a new Mission Santa Clara in 1781, the year Lope Inigo was born. This Serra statue is from the isolated Mission San Antonio de Padua. *Photo by the author.*

given name, Lope, can be a variation of the Spanish word *lobo*, meaning wolf, the name of a strong and independent boy. Inigo's fifteen-year-old sister, Ronsom, was baptized not long afterward and given the baptismal name Emerenciana. It would be five years more before his parents agreed to baptism for themselves.

Why did the Ohlone leave their villages and come to the mission to be baptized? Malcolm Margolin, in his book *The Ohlone Way*, speculates it was the attraction of so many new things that intrigued the Ohlone in these early years: "For a people so thoroughly familiar with their own environment the appearance of something new—a color, a texture, a geometrical shape, a whole new concept of what matter could be—was utterly astounding."[11] By 1793, Mission Santa Clara, the cathedral on the Guadalupe River, had brought in 1,062 Indians to be baptized, an enormous number, considering there were only about half a dozen soldiers and two priests stationed at the mission. By 1795, the number of Ohlone at the mission had reached 1,541, which "depopulated all the Indian villages for miles around the mission."[12]

Many of the early converts were children. The adults may have felt having their children baptized gave them "a foot in both camps."[13] But with Spanish cattle and other livestock now grazing on traditional land and the newcomers discouraging the Ohlone from the fires they had long used to clear the fields for acorn gathering, this may have been a survival strategy. In the winter of 1794–95, the trickle of Ohlone into the mission became a flood, as adults and village leaders began to be baptized in groups of forty and fifty. Inigo's parents, Samis and Giguam, were baptized too. It is not clear if all the new converts understood how this decision would change their lives: once the sacrament had taken place, most were required to live at the mission and much of their freedom came to an end.

Franciscan father Magín de Catala began several big construction projects at Mission Santa Clara in the 1790s. One was a system of aqueducts to bring in water for cooking, washing and irrigation, ensuring there would be enough food for the growing population at the mission. He also ordered construction of a special road, or *alameda*, between the Pueblo of San Jose and Mission Santa Clara—a strong hint to the civilian community to remember to attend mass. Though the willows along the Alameda later brought fame for their beauty, the trees were originally planted as a barrier to protect people from the longhorn cattle grazing along the route. The priests also enlisted Indian workers to plant the mission orchards. An Ohlone born in 1819 at Mission Santa Cruz said his father recalled seeing the first seedlings arrive, "very small, in barrels, so that the roots were kept damp. My father told me," he

Mission Santa Clara, where Lope Inigo was baptized, began its life in 1777 and was moved and rebuilt many times. This James Long photograph shows the last sanctuary Inigo would have known, which burned to the ground in 1926. *Courtesy of History San Jose.*

said, "they had been brought from New Spain."[14] Shoup and his colleagues believe Inigo and his father worked on these and similar projects in the early days of Mission Santa Clara.

In 1797, Inigo was married at the mission at the age of sixteen. His bride was Maria Viviana, another Ohlone convert, who was just fifteen. Baptized when she was a year old, she was from a village the Spanish called San Antonio. Her parents had not converted but had offered each of their eight children to be baptized. Inigo and Viviana's thirty-year marriage would parallel the life of Mission Santa Clara, its establishment, growth, decline and the sorrow and death it brought to their people. Epidemic was a key reason the Ohlone barely survived this era. Of Inigo and Viviana's eleven children, only three would live to become adults.

During the early nineteenth century, Lope Inigo became an *alcalde*, or magistrate at Mission Santa Clara. "His appointment or election to this

position meant that he joined the lower level of the power structure of the mission and was one of those responsible…for governing and controlling the Indians at the mission and ensuring that all necessary work was completed."[15] The job raised his status at the mission and would be important to him later in his life.

Even more interesting is a story told by Juan Bautista Alvarado, a onetime Mexican governor of California, who mentions Inigo in his *Historia de California 1769–1824*, in which he tells of an 1814 fight between Inigo, an Indian friend called Marcelo and Mission Santa Clara priest José Viader. Inigo and Marcelo, both alcaldes and both from the same Ohlone village, were angry enough about something—we don't know what—to attack the priest together. Viader did not turn the other cheek but instead gained the upper hand. "Father Viader captured them…strengthening with this deed the belief that the Great God protects those who serve him on this earth. The Christian generosity with which Father Viader treated the two neophytes made such a favorable impression on the culprits that from that day on they kept a watchful eye whenever danger menaced men of reason."[16] If the two men were punished, it is not recorded. Both continued to live and work as leaders at the mission.

The Alameda, a route between Mission Santa Clara and the civilian settlement of San Jose, was constructed in 1788 by Indian workers. Hill and Watkins took this photograph about a century later. *Courtesy of History San Jose.*

This would not be the last example of Inigo using his fists to stand up for himself. The next one would again involve Marcelo.

The missions were religious dictatorships in which the converts had little freedom. But at least twice a year, the Ohlone were released to go home, and though their villages were mostly abandoned now, they were still able to return to the land they loved. Inigo and his family would have walked the six miles to his old village near Mountain View under an azure sky, over trails covered with native grasses and California poppies. At the ancient site, he and Viviana and the children could build their fires for cooking and gather acorns for traditional bread as they camped under the stars. When the weather was fine, as it almost always is in Mountain View, they could fish in the nearby creeks or walk to the edge of the bay and collect the still-abundant shellfish. For cold nights, they may have brought with them the distinctive yellow-and-white-striped wool blankets woven by the Ohlone at Mission Santa Clara. Though weaving was a skill imported by the Spanish, the yellow for the stripe came from a dye made from local wildflowers the Ohlone had used for many centuries.

The Spanish confessed they never understood the joy the Indians took in these vacations from the rigid regime of mission life. "They see all of this," said Father Fermín Lasuén, meaning the missions, "and yet they yearn for the forest."[17] Said a visitor to the Santa Clara mission in 1816: "This short time is the happiest period of their existence; and I myself have seen them going home in crowds, with loud rejoicings."[18] These respites may have been Inigo's way of maintaining a link with the home to which he one day planned to return.

At the mission, he was active in the band and choir, another tie to his indigenous roots, in which music and dancing had long been celebrated. His teacher in European music was Father Narciso Durán of Mission San José in Fremont, a priest who transcribed his sheet music by hand and was known as the best music teacher in Northern California. Inigo performed at Mission San José and "had a fine singing voice and played instruments well," according to a contemporary report.[19] During this era, other Ohlone music traditions continued: "A few dances were still performed, some surreptitiously, some with the approval of the monks who did not understand their religious nature."[20] A researcher later preserved a single phrase from an Ohlone song that ran: "Dancing on the brink of the world."[21]

For Inigo, these distractions may have been a refuge, since the early decades of the new century were a time of turmoil in California. The Mexican War of Independence, beginning about 1810, left California cut

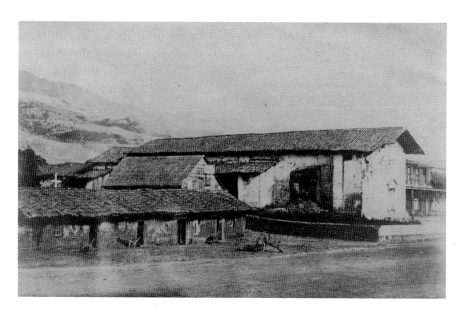

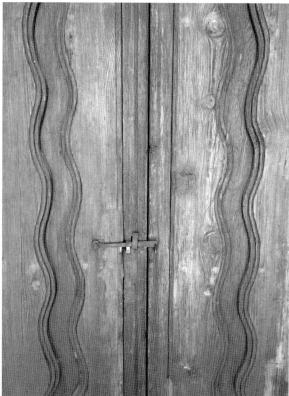

Above: Mission San José, where Inigo studied music, is sixteen miles from Mission Santa Clara, where Lope Inigo spent the first half of his life. Carleton E. Watkins produced this photograph of the mission around 1850, before an 1868 earthquake destroyed the sanctuary. *Courtesy of History San Jose.*

Left: Much of the labor at the California missions was done by Indians. The handmade beauty of their work remains as a testament to their artistry. Original door from Mission Santa Inés. *Photo by the author.*

off from its regular source of resupply. This, in turn, put increased pressure on the missions to produce more products for trade to help feed and clothe the rest of California, not just the priests and their converts. Founded as religious communities with utopian goals, they became dystopian places of backbreaking labor, corporal punishment and very little freedom, before they, too, began to fail.

One of the many reasons for the swift decline of the missions was their terrible death rate. "Under the crowded and depressed conditions, diseases swept through the mission in devastating epidemics."[22] At Mission Santa Clara, 20 percent of the population died during an epidemic in 1802. An outbreak of measles in 1806 killed 16 percent of the population, and another in the winter of 1827–28 killed nearly as many. Indians had little or no immunity to imported diseases, and the Spanish had almost no understanding of how these illnesses spread. The last measles epidemic had a terrible consequence for Inigo. During the outbreak in February 1828, his wife, Viviana, and their two-and-a-half-year-old son, José Tomas, died. Viviana was forty-six years old.

The blow came at a time when the new Mexican government had begun to ponder closing the missions. As Paul Starrs and Peter Goin point out: "The land selected as mission sites includes some of the deepest soils and most fertile agricultural land in California, even today, and the wise choices made then are a tribute to the training and instincts of the mission founders of long ago."[23] Put simply: California coastal land is rich and that makes it desirable. "Every kind of garden plant thrives astonishingly," said an early visitor.[24]

Mission Santa Clara claimed land from Palo Alto to Gilroy and from the Santa Cruz Mountains to San Francisco Bay. With the increase in immigration to California in the third decade of the nineteenth century, new settlers wanted that land. In 1833, the Mexican government secularized the missions—taking them away from the Franciscan priests, turning them into parish churches and parceling out their property. The government assigned an administrator to each mission to handle the transition and said all could apply for land and livestock.

When Mission Santa Clara land became available, Inigo applied. In his favor, he could cite his election as an alcalde and the years he served as auxiliary soldier. Since squatting on land was an agreed-upon strategy for claiming it, he requested legal release for himself and his family and between 1838 and 1839 moved to the site of his old village near Mountain View—a place the Indians called Sojorpi and Inigo called Posolmi—and made a

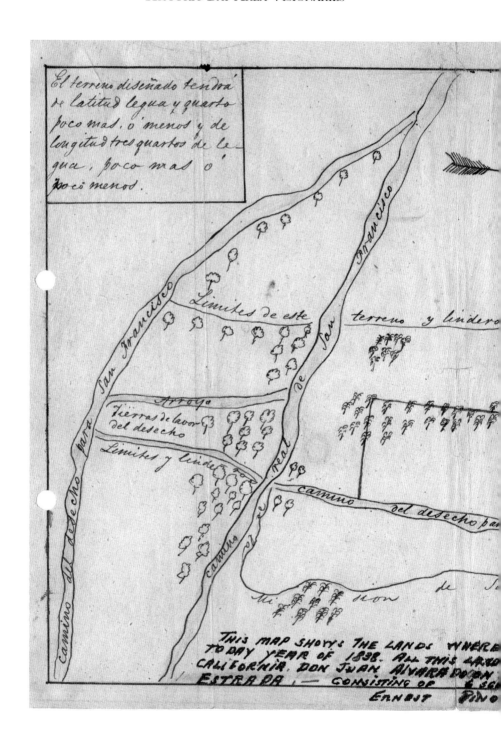

El terreno diseñado tendrá
de latitud legua y quarto
poco mas. ó menos y de
longitud tres quartos de le-
gua, poco mas ó
poco menos.

Limites de este terreno y lindero

San Francisco

de San Francisco

Arroyo

Tierras de labor
del desecho

Limites y lindero

camino real

camino del desecho par

Mi llon de

camino del desecho para

THIS MAP SHOWS THE LANDS WHERE
TO DAY YEAR OF 1838. ALL THIS LAND
CALIFORNIA. DON JUAN ALVARADO AND
ESTRADA. — CONSISTING OF

ERNEST PINO

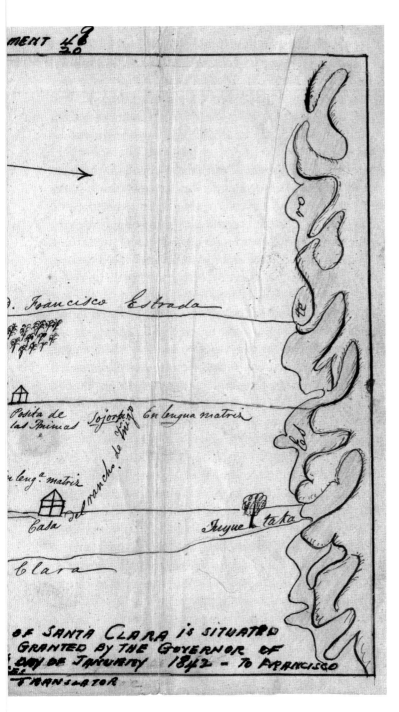

This nineteenth-century map shows locations in the Santa Clara Valley before 1840, including "Casa del rancho de Inigo," and "Posolmi," along with the Ohlone place name "Sojorpi." It shows Inigo was on the property long before his grant was confirmed in 1844. *Courtesy of History San Jose.*

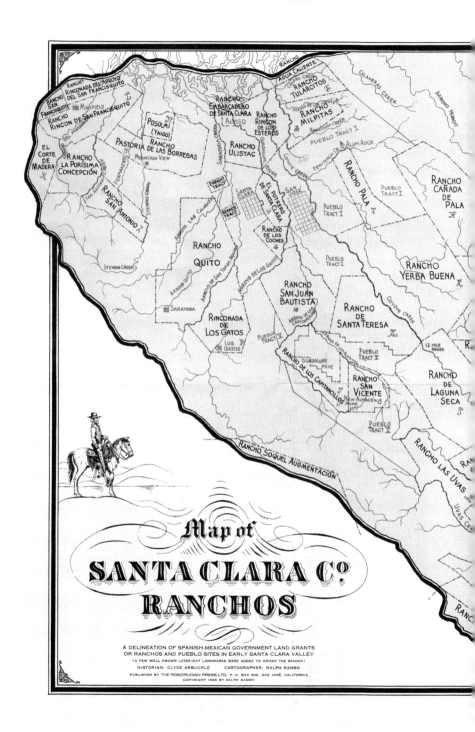

Map of

SANTA CLARA C?

RANCHOS

A DELINEATION OF SPANISH-MEXICAN GOVERNMENT LAND GRANTS
OR RANCHOS AND PUEBLO SITES IN EARLY SANTA CLARA VALLEY
(A FEW WELL KNOWN LATER-DAY LANDMARKS WERE ADDED TO ORIENT THE READER)
HISTORIAN: CLYDE ARBUCKLE CARTOGRAPHER: RALPH RAMBO
PUBLISHED BY THE ROSICRUCIAN PRESS,LTD., P.O. BOX 908, SAN JOSÉ, CALIFORNIA
COPYRIGHT 1968 BY RALPH RAMBO

THE RANCHOS OF SANTA CLARA COUNTY

Lope Inigo's Rancho Posolmi is in the northwest corner of this Santa Clara County rancho map. It sits near Marcelo's Rancho Ulistác and is almost encircled by Rancho Pastoría de las Borregas, owned by Francisco Estrada, who used his influence to gain nearly half the property promised to Inigo. To the west is Rancho La Purísima Concepción, the land owned by Juana Briones. The map was designed by Ralph Rambo, whose uncle worked for Sarah Winchester. *Courtesy of History San Jose.*

interviewed for his article, "The Indian Language of the Santa Clara Valley," was Lope Inigo.[38]

Inigo was affluent enough in 1856 to go to San Francisco and have his picture taken by photographer William Shew. A pioneer friend, Edward A.T. Gallagher, submitted the photo for a story in the *San Francisco Chronicle* in 1903, its first known publication. The *Chronicle* spelled his name "Ynego," called him "the last leaf on the tree" at Mission Santa Clara and quoted Gallagher: "He says his good old Indian friend was a rarely fine old fellow, and that he was as solicitous of the Mission as a mother could be of her first born."[39] If the article is somewhat patronizing, the photograph is a revelation. It shows a neatly dressed, fit-looking seventy-five-year-old. His hands are the hands of a working man. His gaze is steady and his head unbowed.

Inigo lost his second wife and their new baby in 1857, leaving him a widower again at the age of seventy-six. He still had two surviving adult children, a stepdaughter and six grandchildren, though he lost two of his grandchildren in the 1850s. In 1858, his friend Robert Walkinshaw died on a visit to Scotland.

Inigo remained hearty into his eighties. A neighbor, Alfred Doten, reported riding on horseback with him to Mountain View in the spring of 1858: "When I went up this morning, old Ynego rode up with me as far as M.V. The old fellow says when he was a little boy, his tribe was numerous about here, but all have died, and he is the only one left."[40] Inigo also recalled as they rode how grizzly bears were once common and that they, too, had passed from the Santa Clara Valley. Doten later saw Inigo at Mountain View's annual May Day picnic, packing a sack of potluck leftovers to take home.

Inigo lived long enough to see the telegraph line completed between the eastern United States and San Francisco in 1861. In January 1864, entrepreneurs opened a railroad between San Jose and San Francisco with a stop in Mountain View, and the trains, with their steam engines, were another metamorphosis for California and for Lope Inigo. "Inigo…had lived through incredible changes during his long life. The arrival of the railroad, a machine which could travel 40 miles an hour and represented the power available to those who could develop science and technology, was the final change."[41]

On February 28, 1864, a month after the rail station opened, Inigo fell ill. "Telling his friends that he wished to be buried by a cross he had planted, and receiving shortly afterward the blessing of the priest, this kindly

representative of an ancient race passed away."[42] He was buried near the smaller of the Inigo Mounds at Rancho Posolmi. It is worth noting he did not ask to be buried at the mission. His last wish was to be buried at the site of his old village. "He was thus put to rest with many of his own people."[43] He was eighty-three years old.

Robert Walkinshaw's daughters maintained Inigo's grave for many years, keeping its cross in trim and encircling it with a fence. But a reporter who came looking for it in 1917 was told the old Inigo Mounds on the land had recently been leveled off to make room for more rows of alfalfa. With the construction of Moffett Naval Air Station on one thousand acres of old Rancho Posolmi in the 1930s, all the outward markers of his ancient village, the shell mounds and Inigo's grave site, melted back into the earth.

But Inigo himself is still remembered.

Take the light-rail line through the Santa Clara Valley and exit at the Bayshore/NASA stop, near what locals call the Ellis Street Gate at Moffett Field, and you'll be surprised to see a large marker in the shape of an Ohlone basket greet you as you emerge from the train. At its center is the old William Shew photograph of Inigo, inscribed with the details of his life. Born in an Ohlone village more than two centuries ago, this dignified man still has the power to make the modern traveler stop and read.

Once he was among us, dancing on the brink of the world.

2

JUANA BRIONES

THE VISION OF COMPASSION

She was said to have been a warm-hearted,
sincere and good woman who helped those in need.
—Kathryn Daly

There are people in history who jump from its pages and are so distinctive and familiar we almost feel we could walk into a room and begin a conversation with them. Some write their own stories to make sure history is kind to them, as Benjamin Franklin famously did.

There are others we have come to know more gradually through the work of dedicated researchers.

Juana Briones is one of the quieter heroines of California history, yet she has a great story. Writers through the years have called her "the best beloved woman in California"[1] and "one of the most celebrated women of California's Mexican era,"[2] yet she is not widely known. We do know more about her in the twenty-first century thanks to Bay Area resident Jeanne Farr McDonnell's thoughtful biography, which historian Robert J. Chandler said has helped to transform the story of a life well lived into something special.

What Juana Briones did throughout her life was stand up for those in need, finding and retaining the resources to make this possible. She nursed the sick, helped the disenfranchised, cared for runaways, nurtured a large extended family and became such a successful businesswoman, she was able to provide for herself when others would not. In the midst of all this,

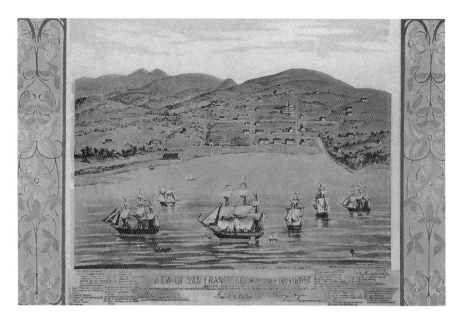

This vintage postcard shows Yerba Buena Cove in San Francisco as it looked when Juana Briones lived there. The city was first called Yerba Buena for the sweet herbs that covered its sandy hills. *Author's collection.*

she also stood up to an abusive spouse—difficult enough today and even more rare in nineteenth-century California.

Though little about the system was set up to aid her, she has not come down to us through history as a victim. In a world of barriers and roadblocks, Juana Briones spent her life with a stepladder, climbing over and around impediments.

California historian Hubert Howe Bancroft was one of the earliest writers to mention her, in his 1884 *California Pioneer Register and Index*, an addendum to his multivolume *History of California*. Most of those listed in his register are men. Spanish California was a patriarchal society based on the hierarchies of the old country, which assumed women were legal adjuncts to male heads of households.

But in his *Pioneer Register*, Bancroft does include a short entry in which he tells us Juana Briones of San Francisco and Santa Clara County was "noted for her kindness to sick and deserting sailors; had an adobe house in N. Beach region in 1836; owner of lot 1841-45. Later claimant for Purísima Rancho, Sta Clara Co. Still living at Mayfield 1878 at very advanced age."[3] In fact, she wasn't just a claimant for Rancho La Purísima Concepción, the

land that later became parts of Los Altos Hills and Palo Alto. Juana Briones owned all its 4,438.94 acres.

That Bancroft didn't leave his office on Market Street in San Francisco and go down the peninsula in the 1880s to interview her in person is indeed a loss. She was in her eighties then, living in Mayfield with her daughters Refugio and Manuela. There was a train directly from San Francisco and had been since 1864. Mayfield was Palo Alto's first town site—roughly surrounding what is now California Avenue. A short train ride and an even shorter walk from the station would have taken Bancroft to Briones's front door. Later in his life, H.H. Bancroft sold his enormous collection of historical documents to the University of California, where the Bancroft Library continues to aid scholars and researchers. But this is one opportunity he missed.[4]

Juana Briones could have told him a lot. She had lived through one of California's most important centuries. Born in 1802[5] into the first generation of Spanish-speaking settlers in California, she lived under the flags of Spain, Mexico, California and the United States and survived into her ninth decade, leaving a comfortable legacy to her children. Unable to read or write, she worked around this challenge, hiring others to help her, as historian Barbara Voss relates: "[H]er words, mediated by the hands of the literate persons who penned them, have claimed a place in the historical record."[6]

Briones claimed and bought property and held onto it through the evolving governments of California, a real accomplishment, since so many others did not. Born when Thomas Jefferson was president of the United States and California was an outpost of Spain, she was an infant when Jefferson sent Meriwether Lewis and William Clark to find a route from the East Coast to the Pacific. When she died, future president Franklin Delano Roosevelt was seven years old, the first skyscrapers were rising in New York City and passengers could hop a train in New Jersey that would take them to the shores of San Francisco Bay.

Juana's mother and her husband's mother came to California during the winter of 1775–76 with their families on the Juan Bautista de Anza expedition. Juana's mother made the trek as a five-year-old, when there wasn't even a road, much less a railroad. Though a handful of priests and a few soldiers had arrived beginning in 1769, these were the first Spanish civilians to come to California. There were only about two hundred of them. Some of the soldiers and missionaries on the previous expeditions, including her paternal grandfather, Vincente Briones, who

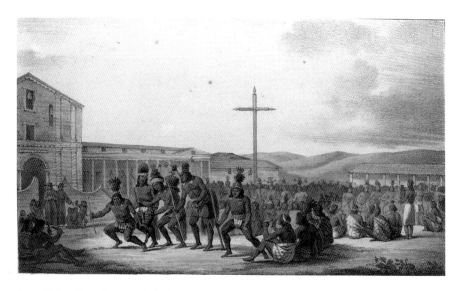

Juana Briones's mother traveled with the Anza expedition as a child and was with the group when it arrived in what became San Francisco. This 1815 Louis Choris lithograph shows Mission Dolores several decades later. *Courtesy of the Bancroft Library, University of California–Berkeley.*

came with Gaspar de Portolá in 1770, had been able to travel at least part of the way by ship—and that had been harrowing enough. But these members of Juana's family made the thousand-mile journey on foot and horseback, as the cattle they brought with them for sustenance straggled along behind.

That they were hearty pioneers is an understatement. When a woman in the group gave birth—and there were several who did so along the way—the expedition stopped for one day so the woman could rest. In fact, a mother in the party gave birth on Christmas Eve 1775, her labor pains coming as the group walked along the foothills of the San Jacinto Mountains. Everyone got a rest that Christmas Day. After a twenty-four-hour break, the new mother would then travel on foot for four or five days, carrying her newborn, until she felt able to resume the journey on horseback or mule.[7]

California has long been known for its beauty, but in 1775, it was truly astonishing. Wild sunflowers and grapes bloomed along the pathways as the pioneers' steps startled herds of elk[8] and antelope. Condors, with their nine-foot-wingspans, flew above them like enormous kites. Birds were so plentiful underfoot, a single covey of California quail could easily outnumber the pioneers themselves.

But California also was full of danger. It was colder than Mexico, and the settlers shivered in their inadequate clothing. The travelers saw grizzlies, awe-inspiring and frightening, since rifles of that era fired only a single shot, and a single shot did not always bring down *Ursus arctos californicus*. The California grizzly could stand six feet tall and weigh eight hundred pounds. Along the route, the group also saw wolves, rattlesnakes, coyotes and cougars. Members of the party awoke one morning to discover a horse had been silently killed in the night, its carcass spirited away by curious Indians.

Juana's antecedents spoke Spanish and came from New Spain—the name of Mexico then—but their histories were diverse. Census records identify her maternal grandfather, Felix Tapia, as being of African and Spanish descent. The same records identify her maternal grandmother, Juana Cárdenas, as being of Indian and Spanish descent.[9] Her father, Marcos Briones, was from the Catalan Volunteers, but even the Catalans, by this time, were multicultural, with a "mixture of Basque, Visigoth, Roman, Greek, Jewish, and Moorish ancestry."[10] Census documents say her father was of African and Spanish descent. He grew up with an Indian stepmother: his mother died, and his father took an Indian wife called Mariana at San Luis Obispo. These families who came with Anza established the civilian settlement they called the Pueblo of San Jose, where the settlers planted the region's first fruit trees and vines, separate from the mission gardens.[11]

Families had a better chance of survival on the frontier, and girls married young. When Juana's parents married in 1784, the bride, Ysadora Tapia, was just thirteen. She would spend much of her time bearing children in the next eighteen years.

Five of Juana's older siblings were born at isolated Mission San Antonio de Padua, California's third Spanish mission, established by Junípero Serra in 1771. Juana's father, Marcos, served as a soldier there during the early years of his marriage, working with Father Buenaventura Sitjar, who spent thirty-seven years working as a priest to the nearby Salinan, Esselen and Yokut communities. Sitjar learned to speak many Indian languages, compiled a Salinan-Antoniaño dictionary and noted "the Salinan Indian language had thirty-four terms to describe various permutations of family relationships."[12]

Since this was a quiet mission, the two or three soldiers assigned there would have had little to do if they had not been given other jobs, according to modern Mission San Antonio administrator Joan Steele.[13] Since a big part of the mission's operating income came from hides and tallow—byproducts

Juana Briones's father served as a soldier at Mission San Antonio de Padua, and five of her siblings were born here. It is still isolated and is the best example of how the others must have looked before they were surrounded by cities. *Photo by the author.*

of the cattle business—Steele noted soldiers like Marcos Briones would have learned the complex process of tanning and tallow production as they worked to teach and supervise. Since hides and tallow later became a big part of Juana's business, her knowledge of production likely came from her father. The remains of the aging tallow vats, nearly covered by wild herbs on the grounds of Mission San Antonio, can still be seen today. Marcos continued doing similar work at his other assignments, including Mission Santa Clara, Mission Carmel and the Monterey Presidio.

Juana was born at a settlement near Santa Cruz called Villa de Branciforte, a village where Catalan Volunteers like her father were given plots of land on which they could retire. During her childhood, nearby Mission Santa Cruz figured in a local scandal that her entire family would have heard about. Father Andrés Quintana served there and was disliked by the local population for his cruel punishments. "The Fathers did not practice what they preached in the pulpit," one Ohlone born at the mission told an interviewer for Bancroft many years later. [14]

In 1812, when Juana was ten, fourteen Indian converts conspired to kill Quintana. Using a gardener called Julián as a decoy, they surprised the priest and strangled him to death in his room. They also removed his testicles,

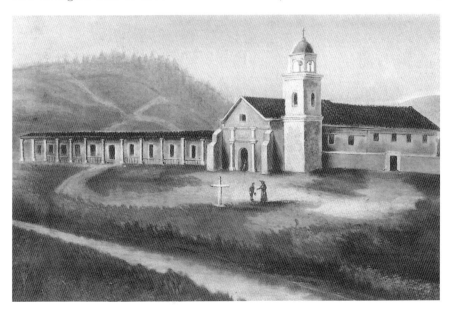

A view of Mission Santa Cruz from a nineteenth-century painting used on a vintage postcard. Juana Briones was born in a nearby village. *Author's collection.*

tossing them into a nearby privy. Then, they undressed Quintana and put him to bed, as if he were asleep. In 1877, an Indian named Lorenzo Asisara, born at the mission, related the story to researchers as it had been told to him by his father: "The Fathers from Santa Clara and from other missions came," he said, "and they held the Father's funeral, all believing that he had died a natural death."[15]

One person eventually talked, the conspirators confessed and Quintana's body was exhumed, confirming the grisly tale. The Church tried the perpetrators in San Francisco, perhaps hoping to keep the story quiet, since Quintana was also rumored to have had a sexual relationship with an Indian parishioner.[16] No one was executed for the murder, and the Indians were punished and returned to the mission.

Whether it was trouble at the mission or other issues, Marcos Briones moved his family from Santa Cruz to San Francisco between 1812 and 1813. Juana's mother, Ysadora, had just died at the age of forty-one and, because of the Mexican War of Independence, Spain had stopped paying its soldiers in California.[17] Marcos may have felt he had a better chance of supporting his family near the larger port and military installation.

San Francisco was not yet a city, nor was it yet called San Francisco, though that was the name of its bay and its fort. Settlers who built homes on its sandy hills kept stepping on "a trailing vine, which, when crushed gave forth a delicious odor."[18] They called the vine *yerba buena*, or the good herb, and Yerba Buena, for a time, became the name of the village. It was home to Mission San Francisco de Asís—more often called Mission Dolores after a nearby arroyo—the sixth mission in the chain, established by Junípero Serra and the Anza pioneers in 1776. About five miles from the mission sat the Presidio above the entrance to the bay. Juana had a married older brother, Felipe, serving at the Presidio, and her twelve-year-old brother, Gregorio, would soon begin training there.

Though Juana was ten when the family moved, she was not in school. One of the failings of the Spanish system was its limited provisions for education—especially for girls. Young girls were expected to work at home, helping to care for their many siblings. Juana's brother Gregorio was literate, as was the man she would marry. But the record suggests Juana was never taught to read or write. All the documents she signed bear only her mark, not a signature.

Perhaps because her father had no income, Juana gained responsibility early. She came to be known as a healer and nurse. "All doors swung open to her in cordial welcome," said one author. She had "learned about herbs

This 1815 Louis Choris lithograph, *View of the Presidio*, depicts the fort at about the time Juana Briones moved there with her family. It shows Spanish soldiers on horseback using lances to control groups of Indians. *Courtesy of the Bancroft Library, University of California–Berkeley.*

from her mother, and other secrets from the Indians."[19] Illnesses were common among the East Bay Ohlone and other Indians at Mission Dolores, made worse, settlers believed, by "the cool, overcast, and windy climate that prevailed year-round." A nurse there never lacked for patients.[20]

As more Americans entered the port, Juana also became an entrepreneur. She tended her father's cattle, dairy cows and chickens and raised herbs, vegetables and fruit,[21] selling her supplies to local residents and sailors from visiting ships. At a time in which nearly everyone she knew either toiled for Spain or lived subsistence lives, Juana was one of California's earliest independent businesswomen.

Juana met her husband when she was a teenager. His name was Apolinario Miranda, a man described in history's kindest mention as "a dull-witted soldier."[22] Records show he was born at Mission Dolores in 1794. "Both of Apolinario's parents were listed in census records as *indios* from the Mexican towns of Pótam and Culiacán, respectively."[23] His father had served under Anza.

Juana Briones and Apolinario Miranda married at Mission Dolores on May 14, 1820. The groom was twenty-six and the bride eighteen. Their first child, a daughter named Presentación, was born a year later. By 1841, they had seven surviving children and adopted at least one more. Mortality rates

Juana Briones had the first adobe in San Francisco on the road between the Presidio and Mission Dolores. She also had another home at or adjacent to the mission itself. *Author's collection.*

were high, and during one terrible year and a half between 1828 and 1829, the couple lost four of their very young children to disease, something even Juana, with all her nursing skills, was unable to prevent.

Apolinario worked at several posts around the Bay Area, including Mission Santa Clara, where their daughter Isidora was baptized by Father Magín Catala. Serving at Mission Santa Clara then were both Lope Inigo and José Gorgonio, another Ohlone. Juana would later buy her rancho from Gorgonio in what were times of great change for California. In 1821, Mexico won its independence from Spain, and in 1822, two years after Juana married, officials in Monterey held a three-day celebration marking the transition. By this time, though, people like Juana no longer identified as either Spanish or Mexican: they had begun to call themselves *Californios*, hoping one day California might gain its own independence. On a dark night when the call went out, "Who goes there?" Juana and her friends might answer: "California *libre*." Free California!

It was as a resident of early San Francisco, where the couple returned, that Juana came to be best known. She was the first woman to build her own adobe, on the route between the mission and the Presidio. There, she tended her cattle, grew her produce and cared for her growing brood. She was so well known, the area around North Beach was first called La Playa de Juana Briones. In 1833, she gave refuge to four sailors who deserted a whaling ship, including one named Elijah, a Connecticut Indian. Sailor Charles Brown said when Elijah fell and broke his jaw, Juana set it and "cured him."[24]

An American named William Thomes remembered her in San Francisco in 1843. He and a shipmate were exploring the port when they found her at her dairy near what became Powell and Filbert Streets. He described her as a "bright, vivacious *señora*," adding: "She always welcomed me with a polite good morning and a drink of fresh milk."[25]

Juana may have been living in her own adobe, apart from her husband, for more than just business. "She of all her family inclined most toward accessing economic opportunity, a temperamental difference that drove a wedge between herself and Apolinario," wrote McDonnell.[26] But the wedge was more likely created by Apolinario's growing alcoholism and physical abuse. Beginning in 1840, when she was pregnant with their last child, Juana reported her husband repeatedly to the local alcalde for battery. An assault in 1841, when her son was just four months old, was so bad, an Indian who managed her business ran for help while another man stood by to protect her. The sheriff threw Apolinario in the guardhouse.[27]

During the 1840s, tiny San Francisco began to grow—especially after the discovery of gold in 1848. As the population increased, so did lawlessness, another reason Juana Briones looked outside the city for a new home. This vintage postcard shows the city in 1849. *Author's collection.*

Juana later testified to a church official that her husband "no longer cares about feeding his family," adding, "[M]y own labor and the labor of my poor family sustain my husband, providing him not only with clothes and food, but also paying for his drunkenness."[28] Bancroft's *Pioneer Register* lists Apolinario's name and profession without comment but ends: "In '43 in trouble with his wife."[29]

It was that year Apolinario was hauled before a magistrate for "not living harmoniously with his wife,"[30] and Juana applied to local officials to have her property titled in her own name. This was technically legal for married women under Mexican law, but it was rare. Juana was not deterred. Since divorce was not an option for her as a Catholic, she appealed to the church for a clerical separation. Secularization of the missions in 1833 had left Mission Dolores without a priest,[31] but even that didn't stop Juana. She got on a horse and made the three-day journey to Mission Santa Clara, where she knew the priest, and asked for help.

Juana's words, in her 1844 application for separation, were taken down by a scribe and have survived. She testified:

> [A]*s soon as he is a little tipsy he begins to utter his blasphemies, swear, and to put into practice his abominable behavior, not only publicly and imperiously demanding the conjugal debt from me, but also wanting to abuse it, as he has tried to do several times with my daughter María Presentación....*
>
> *Your Lordship, my husband is the greatest obstacle placed before my children, because from him they learn nothing but swearing, blasphemy, and ugly, lewd, and dissolute behavior. How will I excuse myself before God, if I do not seek, as much as I can, all possible means of ridding my family of such a bad example?* [32]

When Bishop García Diego read the deposition, with its lurid charges, he immediately asked the magistrate at Yerba Buena to "take measures to protect her."[33] Though it is unclear if a separation was granted by the church, it seems likely this was the outcome, since, beginning in 1844, documents often refer to Juana Briones as a widow, though her husband remained alive.

Abusers control their victims by manipulation and intimidation as well as violence, but this does not seem to have worked with Juana. During this period, she renewed her acquaintance with José Gorgonio, the Ohlone she knew from Mission Santa Clara. Gorgonio had been granted Rancho La Purísima Concepción in 1840 with his son, José Ramón. With more Americans flowing into California in the years just before the Gold Rush, Indians in the region began to face violent pressure from settlers, squatters and marauding bands of Tulare Yokuts out of the San Joaquin Valley. During this period, it was Yokuts who burned down Gorgonio's ranch house, injured his son and daughter-in-law and stole his horses during a raid. "The Yokuts apparently saw Gorgonio as simply another Mexican *Californio*."[34]

About 1844, Juana purchased the property from Gorgonio, with funds she had saved from her enterprises in San Francisco, asking Gorgonio and his family to stay on and manage her cattle business there. For her part, the purchase gave Juana property on which she could work a safe, thirty-seven miles down the peninsula from her husband.

On land that is now in Palo Alto, she built her house at Rancho La Purísima—often during her lifetime called Rancho Briones—possibly with the help of Charles Brown, one of the deserting sailors she had befriended years before, now working as a sawyer in the nearby redwoods. In 1848, surveyor Chester Lyman stayed with her while he worked to confirm her ranch boundaries. "The family is composed of the Widow Briones," Lyman

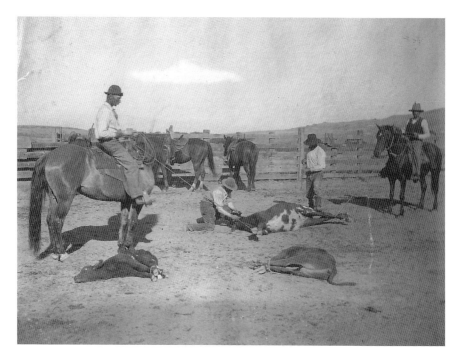

Cattle ranching dominated California during the Spanish and Mexican eras, and many of the *vaqueros* were of Indian heritage. Cattle were valuable, giving ranchers like Juana Briones a lucrative business. This A.P. Hill photo shows a Santa Clara Valley roundup circa 1902. *Courtesy of History San Jose.*

wrote, "three daughters (two grown up), two or three boys, half a dozen Indians, two pet pigs in the cookhouse and fifteen or twenty dogs....There are two sick persons in the house, an Indian girl of fever, and a man, a sailor apparently a Portuguese, who has a very bad cough."[35] The sick and ailing in her household are further evidence of Juana's continued compassion for others. By this time, she had also legally adopted an Indian orphan named Cecilia, just one of the motherless children history tells us she cared for. Her last child, José Aniceto—often called Dolores—was born with a disability and would need her help all his life.

Her husband, Apolinario, died in 1847 at the age of fifty-four. In one of the last ironies of their fractured relationship, Juana, as his widow, inherited their property in her name. She hired lawyers to prove up her claims in the U.S. courts after 1850 and was successful in all of them, taking the case of one San Francisco property—and winning—all the way to the Supreme Court of the United States.

IS THIS JUANA BRIONES?

For many years, there were no photographs of Juana Briones. In 2007, descendants of the Garcia family, into which Juana's family married, donated this photo to a Marin museum, saying they believed it was Juana Briones. It is a platinum print, which only came into vogue in the 1890s, after Juana's death. But an expert pointed out platinum prints were often reprints of older photos, and it does bear a resemblance to Juana's family. It remains one of the mysteries related to her life. *Courtesy of the Point Reyes National Seashore Archives.*

Over the years, the cattle business began to decline in California, and shortly after the Gold Rush, the Santa Clara Valley began to transform itself into center for commercial orchards. Jeanne Farr McDonnell makes the case that Juana turned to orchards early, likely planting some of the first apricot trees in the hills above Los Altos. She points to the origins of fruit growing in the mission gardens and the Pueblo of San Jose, which Juana knew from her childhood, and to the fruit trees Juana and her husband planted on less fertile soil in San Francisco. McDonnell cites the surviving apricot orchard at Alta Mesa Memorial Park in Palo Alto, on land Juana left her son Tomás Miranda. Ranch records show Juana hired Chinese laborers, and the Chinese were noted for their work in agriculture, not ranching. There have been orchards surrounding the Taaffe House in Los Altos Hills for many, many years, on land Juana owned and sold pioneer Martin Murphy for his daughter Elizabeth Taaffe. It makes sense that a businesswoman like Juana Briones would have been an early adopter in joining a profitable new industry.

As the years went by and California became the thirty-first state of the Union, Juana regularly went from her rancho to San Francisco, a three-day journey each way by *carreta*, a cart pulled by oxen. In San Francisco, she took

her hides to "Davis or to Leidesdorff, the two most successful merchant-shipowners of the time, exchanging them for needed supplies."[36] At the ranch, she continued to secure her boundaries, and the new American courts confirmed her ownership in 1854, 1863 and 1871.

She never lost her ability to celebrate. Every summer, she hosted a fiesta at her ranch, and the guests included her grown children, grandchildren, siblings and all their families. They grilled beef in the late afternoons as the children played in the shade of the old oaks. In the evenings, everyone danced in the moonlight. Juana's sister Guadalupe came over from Half Moon Bay, bringing her musical family with her, "which within its own circle formed a whole brass band and added much to the gaiety of the occasion."[37]

There is a story that outlaw Joaquin Murrieta sought refuge at Juana's ranch one day as he escaped from one of his adventures. The tale says Juana was willing to give him her protection but wanted nothing to do with his stolen loot, so he buried the money on her ranch and died before he could reclaim it. Since Murrieta is himself a legend and the story is attributed to an unreliable Miranda grandson who told the tale from a San Francisco barstool—it should be considered just a story. But that does not stop people from wanting to believe it.

Juana Briones built her home on what became Old Adobe Road in the foothills of the Santa Cruz Mountains. Though the house ended up within the city limits of Palo Alto, most of her land became Los Altos Hills. The structure was razed in 2011. *Courtesy of the Palo Alto Historical Association.*

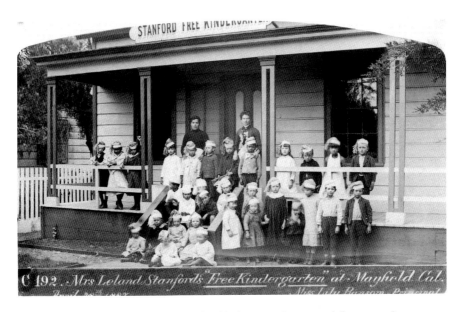

In 1886, Jane Stanford established this free kindergarten just around the corner from Juana's Mayfield home. The photo must have been taken during a celebration, since all the children are wearing party hats. *Courtesy of the Palo Alto Historical Association.*

Juana remained at her home in the gentle California foothills until she was elderly and suffering from rheumatism. When she finally moved, in 1884, it was to a home in Mayfield—now part of Palo Alto—just three miles away, near the corner of what is now Birch and Page Mill.[38] There, she was closer to two of her married daughters, her beloved church and a railroad station, where a train could take her to visit San Francisco, her old hometown.

By the time she was in her eighties, she was wealthy and had so prospered, she owned more than half a dozen properties in Mayfield alone. Her grandchildren and great-grandchildren were able to attend public school, a benefit not available to her. The toddlers were eligible for something really new—a kindergarten founded by her neighbor, educational innovator Jane (Mrs. Leland) Stanford, in a rented house just around the corner from Juana's Mayfield home.

Juana de la Briones y Tapia de Miranda died on December 3, 1889, and was buried in Holy Cross Cemetery in Menlo Park.

Her house at the ranch, on what became Old Adobe Road, survived into the twenty-first century, but it was finally razed in 2011. Preservationists saved a wall of the house to become a centerpiece of exhibits about her. An elementary school and a park in Palo Alto are named for Juana Briones.

At the end of the nineteenth century, there was one writer who came to California and took almost no time to work on his tan. In the midst of both a health crisis and a complicated personal life, this visitor had the vision to see something his contemporaries did not. In a land obsessed with newness—a reasonable description of California in almost any era—he was one of the first to advocate in the popular press for historic preservation. His words helped save important pieces of California history for generations yet to come.

But it didn't begin that way at all.

Robert Louis Stevenson did not travel thousands of miles from his home in Scotland in 1879 on a mission of mercy to California history. He wasn't, initially, even working on a book.

Robert Louis Stevenson was chasing a woman.

He had met Indiana-born Frances Van de Grift Osbourne, known as Fanny, at a bohemian gathering in France in the autumn of 1876. Modern writers still debate her charms, but her contemporaries—especially the men—did not equivocate. "She was the only woman in the world worth dying for," wrote her San Francisco friend Ned Field after her death. And he was forty years younger than she.[2] Writer Claire Harman described Fanny this way: "Tiny in stature and not conventionally pretty…Fanny exuded a sexual aura that many men found irresistible."[3]

Fanny was a California resident visiting France to study art. Their meeting, in the artist colony of Grez-sur-Loing, was electric. Stevenson said he first saw her in the candlelight through the half-open door of a restaurant and had fallen in love with her as he stood outside on the street. That, at least, is part of the legend.[4]

She was an unusual choice for a young man from a wealthy and pious Edinburgh family. She was almost eleven years older than he, for one thing. For another, she was married and had been for more than twenty years. Using her art studies as an excuse, she had traveled to Europe to put some distance between herself and her husband, Sam Osbourne—a miner, court clerk and serial philanderer. He was one of the founders of San Francisco's famed Bohemian Club. Fanny was traveling with her two surviving children in mourning, having lost her youngest child, a four-year-old boy, shortly before she and Stevenson met.

Stevenson, born in 1850, was escaping, too—from the suffocating life in Scotland of a pampered only son. His step-great-grandfather and grandfather had been famous Edinburgh engineers, and his father, Thomas, was now a successful partner in the family firm, Stevenson & Sons. The company was

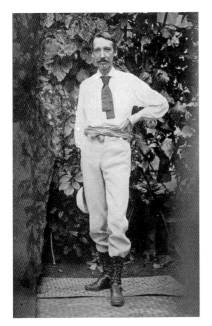 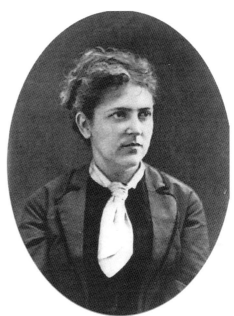

Left: Robert Louis Stevenson, seen here in Samoa, was the only son of doting parents who often wished he would live a more conventional life. But almost nothing about him was conventional. *City of Edinburgh Council—Libraries.*

Right: Fanny Van de Grift Osbourne in a photograph popularized on a vintage postcard. She was older than Robert Louis Stevenson, unhappily married and the mother of two young children when they met in France. *Author's collection.*

renowned for its construction of the lighthouses along Scotland's dangerous coast and for the innovative gas lanterns of Edinburgh. Stevenson's father sent him to Edinburgh University to study engineering, but he showed no aptitude for it and rarely attended class. After three years, he admitted engineering didn't interest him, so Thomas Stevenson insisted he study law, since being a writer was not, in the father's opinion, a proper job. Law, unfortunately, was another profession the young man did not want to pursue. Though once again he played the truant, Robert Louis Stevenson—much to the amazement of his friends—was able to pass his bar exam in 1875. His parents were so proud they had a brass plate installed outside their door that read "R.L. Stevenson, Advocate." But he only appeared in court to advocate on one occasion.[5]

He had always wanted to be a writer and would do nothing else. When Stevenson met Fanny, he was in France with a ragtag group that included

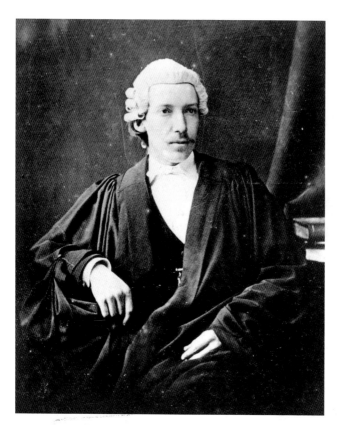

Robert Louis Stevenson in the court dress he wore when he qualified to serve as an advocate in Scotland. He passed his bar exam, but the records show he only appeared in court once. *Courtesy City of Edinburgh Council—Museums and Galleries of Edinburgh.*

his cousin Bob Stevenson and a gaggle of their literary friends, and he was working on a series of essays he hoped to have published.

The romance between Fanny and Robert Louis Stevenson blossomed, and his return to Scotland did not end it. The two exchanged letters, and for the next two years, while he worked on a book and she painted, Stevenson dashed back and forth from Scotland to France to see her. He was not yet the internationally acclaimed, financially successful author he later became with books like *Treasure Island* and the *Strange Case of Dr. Jekyll and Mr. Hyde*, so his travels were made possible only through a generous allowance from his father, to whom he finally confessed the relationship in 1878. Thomas Stevenson and his wife had been aware of their son's liaison for some time, and though they did not approve, their son was now a twenty-eight-year-old man. For the present, Thomas Stevenson kept his council, hoped the affair would pass and did not "make any threats about money."[6]

When Fanny decided to return to her husband in Oakland, Stevenson's parents were relieved, but the young writer was devastated. He had never

A vintage postcard view of Edinburgh from Raphael Tuck and Sons. Stevenson had weak lungs, and in the nineteenth century, the coal fires used to warm the houses of Edinburgh left a pall over the city that was not good for Stevenson's health. *Author's collection.*

been in robust health and was already suffering from lung disease. At five foot, ten inches and 118 pounds, he did not have a huge well of physical reserves. He spent many days of the next year laid low by illness, spending his healthy hours focused on his writing and on the misery he felt at being separated from Fanny.

In the late summer of 1879, he received word Fanny had again left her husband, this time moving with her children to Monterey, California. Stevenson made plans to follow. Whether it was a telegram saying she was ill, as some sources report—and Fanny was always dramatic about her health—or whether he had intended to follow her all along is not clear. Whatever the trigger, on August 7, 1879, Robert Louis Stevenson took a train to Glasgow, where he boarded a ship bound for New York. He left a forwarding address with just one friend and said it should be given to "no one, not even the Queen."[7]

It is not necessary to exaggerate the difficulties involved in a journey of this distance in the early years on the leading edge of modern travel. Stevenson's ship, the *Devonia*, was a steamer, so it was more reliable than a sailing ship; nevertheless, it took ten days to cross the Atlantic to New York. The second leg of the journey, on the recently completed first

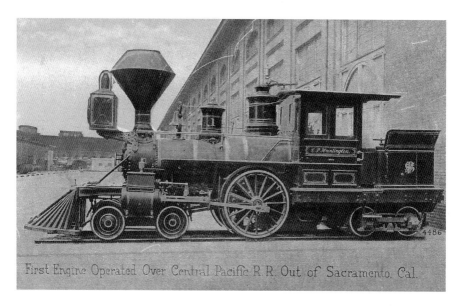

First Engine Operated Over Central Pacific R.R. Out of Sacramento, Cal.

The first engine that operated over the Central Pacific Railroad out of Sacramento on the first transcontinental railroad, a vintage postcard created by the Pacific Novelty Company. The line was completed in 1869, and Stevenson would travel on it just ten years later. *Author's collection.*

transcontinental railroad across the United States, would take nearly two weeks more through the still-unsettled Plains of America. When Stevenson traveled on this engineering marvel, the first of its kind in the world, the Battle of the Little Bighorn was just three years in the past.

The secrecy of the trip left Stevenson with very little money, so he booked a second-class ticket—officially called "second cabin"—on the *Devonia*, just a notch above steerage. He had romantic notions about the joy of traveling among the common people but found his accommodations were so bad he could hear the steerage passengers being sick through the thin walls of his cabin. The food was revolting, and the bedding was worse—it was infested with lice, which plagued him, covering his body with itchy sores.

In spite of it all, he was a cheerful traveler. He began taking notes, as he decided his adventure, whatever its outcome, would be great material for a book. On board the *Devonia*, when the weather was fine, he spent his time on deck with the other travelers. Most, who did not share his prosperous origins, were looking for a better life in America. "Not a tear was shed on board the vessel," he wrote. "All were full of hope for the future, and showed an inclination to innocent gaiety. Some were heard to sing, and all began to scrape acquaintance with small jests and ready laughter."[8]

Back in Edinburgh, his parents were frantic. When they figured out where he had gone, his father wrote a friend: "For God's sake use your influence. Is it fair that we should be half murdered by his conduct? I am unable to write more about this sinful mad business. Our case is painful beyond expression."[9] In the end, concern for his son prevailed, and Stevenson's father "relented enough to send him a sum of money to the New York post office, general delivery, thinking his son would of course go there for mail on reaching the metropolis."[10] Robert Louis Stevenson did look for mail in New York but, for some reason, missed the message and the money from his father.

By the time he arrived in New York, he had lost fourteen pounds from the bad food, seasickness and the other ailments he had suffered. His train for the West did not leave until the next day, so he found a room at a boardinghouse and spent a full day walking the streets of New York, doing errands in a driving rain. He changed his pounds into dollars, bought his rail ticket, looked for messages from Fanny and dispatched a short story he had written off to London.

He also went to a bookstore and invested his limited means in something to read on the route. His choice of reading material was not light, in any sense. He began his three-thousand-mile cross-country train trip lugging George Bancroft's *History of the United States of America* in its six-volume edition.

Stevenson's ticket would take him on America's first transcontinental railroad—something truly extraordinary. Until its inauguration in 1869, California was isolated—though the news of the gold strike in 1848 had nevertheless drawn hundreds of thousands of adventurers in spite of the difficult travel involved. Going around Cape Horn to California by sea could take as long as six months from the East Coast of the United States. Going over the Sierras by wagon, by mule and on foot could take just as long and was much more physically demanding. Crossing at the Isthmus of Panama was shorter, but the trip involved swamps and the risk of deadly fever. "California became a magnet for the argonauts from around the world, especially from the United States, but it must be doubted that ever before had such a desirable place been so isolated."[11]

Engineers in other countries said a railroad across the United States could not be done. The Rockies and the Sierras could not be crossed by rail. But as historian Stephen Ambrose wrote, the first transcontinental railroad was just one more interesting thing from the mind of president Abraham Lincoln, who nurtured and encouraged it and, in the end, signed the bills that made it happen. "Next to winning the Civil War, and abolishing slavery, building the first transcontinental railroad from Omaha,

Nebraska, to Sacramento, California, was the greatest achievement of the American people in the nineteenth century."[12]

As Stevenson would discover, this was not just one railroad—it was a collection of them operating on lines extending from New Jersey to San Francisco Bay. Passengers had to disembark several times, sometimes walking as much as a mile to a new station to catch the next train. Stevenson often jumped off at stations anyway, looking for mail or cables from Fanny, and spent much of his trip worrying about what would happen when he saw her. At Council Bluffs, Iowa, he was so exhausted, he left the train and checked into the Union Pacific Hotel. Though it delayed his travel, it gave him a rare chance for a meal, a bath and a good night's sleep.

Almost everything about the trip was uncomfortable. Most of the rail cars were filled with narrow wooden bench seats that didn't have any padding on them. Dining cars, if they existed at all, were designed for first-class passengers, which Stevenson was not. Hungry travelers had to dash off at station stops looking for meals, hoping the train wouldn't pull out while they were eating and leave them behind. When an engineer was trying to make up time, sometimes the train wouldn't stop at all and the passengers would go hungry. There was a train toilet, but it was just an enclosed cupboard (with a chamber pot) at the back of each car.

Downtown Council Bluffs, Iowa, in a vintage postcard view. When Stevenson reached Council Bluffs and checked into the Union Pacific Hotel, he was just halfway in his 2,819-mile journey across America. *Author's collection.*

Then there was the danger. Heating came from wood-burning stoves and lighting from kerosene lamps. Under the circumstances it isn't surprising that the wooden cars, pulled by steam engines that burned wood and coal and spewed sparks, not infrequently caught fire. Signaling systems were primitive, and there was a growing problem with head-on collisions.

And yet Stevenson was fascinated. Taking the train across America in 1879, he was riding a wave of change. He was traversing a young country on something far more comfortable than a stagecoach or a covered wagon—the prevailing technology just a decade before. His fellow travelers gave him the nickname "Shakespeare," as they watched him constantly writing about what he saw. He was seeing the breadth and beauty of America before it was covered with roadways, highways, smokestacks and sprawl. He often stood on the observation platform on the back of his train, marveling at America and drinking in its air. "It had an inland sweetness and variety to one newly from the sea," he wrote as the train traveled through the farmland of Pennsylvania and Ohio. "It smelt of woods, rivers and the delved earth."[13] He loved the sound of American words: "[S]usquehanna, the beauty of the name seemed to be part and parcel of the beauty of the land," he writes in *Across the Plains*. And the Plains, he wrote when he reached Nebraska, spread out like the ocean. "I spied in vain for something new. It was a world almost without feature, an empty sky, an empty earth."[14] In Scotland, he had read and loved the poetry of Walt Whitman. Now he better understood the poet's vision of this enormous young country.

Coming down from the Sierras, as the forests and canyons flew past the train's windows, many of the passengers gathered to gasp at the views and dream of their futures in the Golden State. "Not only I," wrote Stevenson, "but all the passengers on board, threw off their sense of dirt and heat and weariness and bawled like schoolboys."[15]

After arriving in Oakland, he took a ferry to San Francisco. "The day was breaking as we crossed the ferry," he wrote. "[T]he fog was rising over the citied hills of San Francisco; the bay was perfect—not a ripple, scarce a stain, upon its blue expanse; everything was waiting, breathless for the sun."[16] He did not pause in what was even then one of the world's most famous cities. He caught yet another train, this one bound for Monterey. Robert Louis Stevenson finally arrived in what he called "the old Pacific Capital" and found his way to the house where Fanny was staying with her sister and two children. He had been on the road for almost a month.

He must have been quite a sight. He had lost even more weight on the train, and his ears, neck and hands were covered with an itchy rash.[17] By

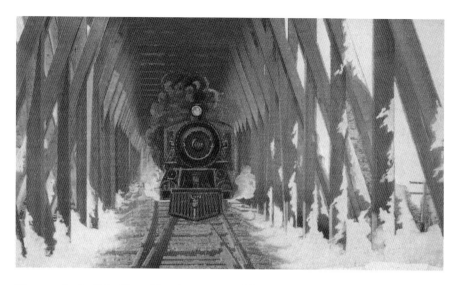

The snowsheds of the Sierra Nevada were one of the many innovative features of America's first transcontinental railroad. "When I awoke next morning, I was puzzled for a while to know if it were day or night…and found we were grading slowly downward through a long snowshed," wrote Stevenson. *Author's collection.*

now he weighed only about 109 pounds, and a friend who saw him months later said he was so thin you could "put your thumb and finger round his thigh."[18] Though there were cries of delight at the reunion and Stevenson and Fanny held one another and wept, it was clear the writer had paid a terrible price for his adventure. Fanny's son Lloyd, then just eleven years old, recalled: "His clothes, no longer picturesque but merely shabby, hung loosely on his shrunken body."[19] Fanny said his teeth looked so bad she thought he should have them all pulled out and have some false ones made for him by an American dentist.

Worse yet, Fanny was still deliberating. She was not yet ready to leave her husband and marry Stevenson, which is what the writer wanted. It probably did not help that the man who had crossed six thousand miles to propose marriage was now ailing and penniless, apparently cut off from his wealthy family. Fanny protested she was in Monterey not because she had left her husband but because she was continuing to study art. Her husband, Sam, was supporting her and making frequent visits. The situation was still full of complications.

But the complications in Stevenson's life turn the tale for California. His heart may have been in turmoil and his health may have been bad, but his

The former California capital of Monterey was just a rustic fishing village when Robert Louis Stevenson saw it in the fall of 1879. He reunited with Fanny Osbourne there. *Author's collection.*

creative vision remained intact. He now began to observe and write about the things he saw around him in the exotic new world of California. He rented a room in an adobe called the French Hotel and arranged to take his meals at a local inn run by Jules Simoneau, who would become a lifelong friend. Then he set out on a hike through the Carmel hills, where he spent three weeks writing in his notebook and camping with just a backpack and a few provisions.

He barely survived. At one point, two goat ranchers found the writer unconscious under a tree and had to take him in and nurse him back to health. But it was on this hike Stevenson glimpsed Mission Carmel for the first time.

He wrote:

> *The church is roofless and ruinous, sea-breezes and sea-fogs, and the alternation of the rain and sunshine, daily widening the breaches....As an antiquity in this new land...it* [has] *a triple claim to preservation from all thinking people; but neglect and abuse have been its portion. There is no sign of American interference, save where a headboard has been torn from a grave to be a mark for pistol bullets.*[20]

He told his friends he was shocked by the way California had treated its Indians, some of whom were still living in improvised dwellings around the old missions.

Just five miles south of Monterey, Mission San Carlos Borromeo del Río Carmelo sits above the mouth of the Carmel River on the edge of the Pacific Ocean. Founded in 1770 by Father Junípero Serra as the second Spanish mission in California, it became headquarters of the string of twenty-one missions that stretched from San Diego to Sonoma. In many of them are the origins of California's first modern cities and towns.

Designed to help Spain create a colonial foothold on the West Coast of North America and bring Catholic teaching to indigenous people, the lives of the missions were relatively short. They were established in the last decades of the eighteenth century and the first decades of the nineteenth, and Spain ceased to subsidize them in 1810. When Mexico gained independence from Spain in 1821, support eroded further, and in 1833, the missions were secularized, with much of their land given away. Most of the Franciscan fathers packed up and returned to Mexico or Spain.

Things changed again after gold was discovered in 1848. California was flooded with newcomers bent on seeking their fortunes. Few had any interest in what they saw as "useless relics of a bygone civilization."[21] Though some missions became parish churches and formed the foundations of towns like San Luis Obispo and Santa Barbara, others were abandoned. John C. Frémont, a leader of the Bear Flag Revolt in California, encouraged early pioneers to stay at what he described as the "mostly unoccupied missions." Soldiers used Mission San Diego de Alcalá as a stable. Farmers used Mission San Juan Capistrano as a barn. So many pioneers squatted at Mission Santa Clara, it earned the nickname "The California Hotel." The mistress of its last Franciscan priest turned one of its buildings into a fandango parlor, and the Jesuits had to buy it back from her when they decided to create a college there, now Santa Clara University.[22]

Few California travelers, it appears, were like Robert Louis Stevenson. Few came calling with six volumes of American history in their knapsacks.

Returning to Monterey from his Carmel hike, Stevenson took a job writing for the *Monterey Californian* newspaper, a position apparently subsidized by his friends. The small stipend gave him something to live on, and the paper gave his ideas a platform. He learned the priest at the Royal Presidio Chapel in Monterey held an annual service at the Carmel mission for the Ohlone and Esselen families; many had scattered at the end of the mission era, but some still practiced their Catholic faith. In November 1879, on the feast day of

The ruined Carmel Mission in a vintage postcard. Stevenson, born in Scotland, was accustomed to being surrounded by ancient buildings. He was astonished to see California allowing its history—for example, Mission Carmel—to dissolve into dust. *Author's collection.*

The Robert Louis Stevenson House in Monterey, California, is now a California state park. The old adobe was a rooming house when Stevenson stayed there in 1879. *Author's collection.*

Saint Carlos Borromeo, Stevenson attended the mass and wrote about the service, held in the only part of the church that still had a roof.

"An Indian, stone blind and about eighty years of age, conducts the singing; other Indians compose their choir; yet they have the Gregorian music at their finger ends and pronounce the Latin so correctly that I could follow the meaning as they sang,"[23] wrote Stevenson, who apparently had retained some of the Latin he claimed not to have studied to pass the bar in Edinburgh. In the November 11, 1879 edition of the *Californian*, he urges residents to begin a preservation campaign to save the mission: "[W]hen Carmel Church is in the dust, not all the wealth of all the States and Territories can replace what has been lost."[24] Many years later, a friend from Monterey remembered how the service "made a deep impression on Stevenson."[25]

Others may have thought as he did. But Stevenson's voice was one of the first—and as his literary fame grew, certainly one of the most prominent—to be raised for the preservation of the California missions and the other original adobe buildings. According to California park ranger and Monterey historian Michael D. Green, "Stevenson made the locals in Monterey pay attention to their history. That's how so many adobes were saved." And though it took many years and many more voices, early efforts to save and restore the historic structures began at Mission San Carlos Borromeo del Río Carmelo, where, in 1882, Father Angelo Casanova initiated a campaign to stop vandalism of the mission ruins.[26]

Over the years, church congregations, wealthy philanthropists, historical clubs, the State of California and, during the Great Depression, the federal government, also became involved. Some California Indians became preservationists too, including Salinans Eusebio and Perfecta Encinales and their families, who continued to live near Mission San Antonio de Padua and sent workers to aid in the restoration.[27] Cowboy film star G.M. "Broncho Billy" Anderson—born into a Jewish family—sponsored a fundraiser in the early twentieth century in Niles, California, to help raise money to restore old Mission San José.[28]

In the early twentieth century, the original Spanish and Mexican adobe buildings and the missions themselves became popular symbols of California history and big draws for tourists. Their earth-toned hues and handmade beauty caught the attention of artists and architects already in the sway of the Arts and Crafts movement, who copied their styles in California's public and private buildings. In the old missions and adobes are the origins of Mission Revival architecture and the ubiquitous California ranch-style house.

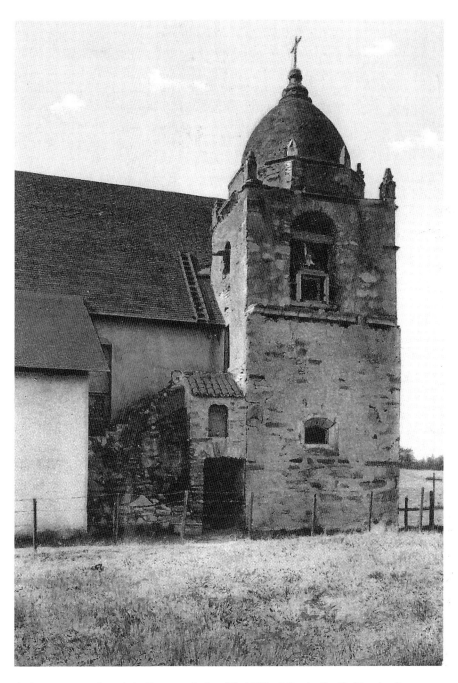

A vintage postcard made in Germany before World War I for the Pacific Novelty Company shows a new roof on Mission Carmel. Father Angelo Casanova began the restoration in 1884, work greatly enhanced by architect Harry Downie in the 1930s. *Author's collection.*

In the middle of the twentieth century, historians began to reassess the romantic view of the Spanish and Mexican eras, seeing them more harshly as eras of European oppression in the New World. In the twenty-first century, some scholars have assessed again, coming to view the missions and adobes as unique sites containing irreplaceable data and art, representative of the many cultures that intersected and created California.

Work at various missions has uncovered Spanish, Moorish, Mexican American and Indian art and decorative motifs that exist nowhere else in the West. In 1954, at Mission Santa Inés, workers found two enormous paintings in a box. One of them, *Christ at the Well of Jacob*, was restored in 2002 and discovered to be seventeenth-century Mexican in origin, signed "Geronimo Gomes fecit." Translated from the Latin, the phrase means: "Geronimo Gomes made this." The date and signature suggest an artist, three centuries in the past, whose origins were Spanish (Geronimo is the Spanish version of the name Jerome), Portuguese (Gomes is a common Portuguese surname, akin to Jones in English) and Mexican (Mexico is where the painting was created). The otherwise unknown artist produced what is now a multicultural California treasure.

Down the hall at Mission Santa Inés is another treasure: an early nineteenth-century oil of the archangel San Rafael painted as a Chumash warrior, executed by an unknown Chumash artist. Docent Paul Melançon gets many calls from those who would like to see this painting and says it is one of the most coveted works of art in the state.[29]

At the northernmost mission, San Francisco Solano, founded in 1823 in Sonoma County, research enabled the state to install a plaque listing the baptismal names of 837 Miwok, Wappo, Patwin and Pomo people buried there—the only such memorial in the state of California.

If Robert Louis Stevenson's difficult journey circuitously brought about a benefit to historic preservation in California, it didn't turn out badly for him, either. Shortly after he returned from his Carmel hike, Fanny Osbourne agreed to marry him. Returning to Oakland, she found a lawyer and filed for divorce. Her husband did not oppose the suit, and Stevenson and Fanny were quietly married in San Francisco in 1880, traveling to the Napa Valley to celebrate. Robert Louis Stevenson was so in love, he had his teeth pulled, replacing them with a set of false ones, to please his wife.

With Fanny at his side, the writer returned to Scotland and reconciled with his family. More mature than he, Fanny turned out to be a great mediator between her talented husband and his complicated parents. Spent living in Scotland, England and Switzerland with Fanny, Stevenson's next few years

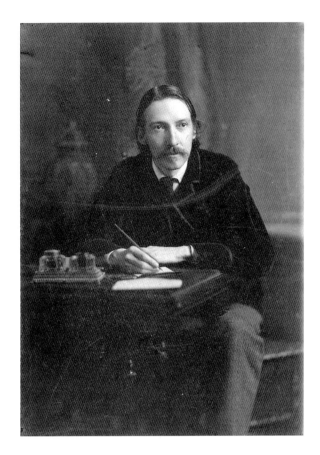

A photo portrait of
Robert Louis Stevenson
by Bartlett F. Kenney of
Boston, produced in 1887
on Stevenson's second
visit to the United States.
He is wearing his favorite
blue velvet jacket, which
he sports in many of his
photographs. *Courtesy
Portraits Collection (PC_PT
00255) California Historical
Society.*

were the richest of his creative life and included the publication of *Treasure Island* (1883), *A Child's Garden of Verses* (1885), the *Strange Case of Dr. Jekyll and Mr. Hyde* and *Kidnapped* (1886), along with three books about California, including *The Silverado Squatters* (1893) and *Across the Plains* (1892), the story of his trip across America on the railroad. He became celebrated around the world and wealthy beyond his dreams. With a loving marriage and fulfilling work, Stevenson lacked only time.

Though he and Fanny traveled back to the United States and then on to the South Pacific seeking a better climate for his health, his lung disease progressed—not helped by his habit of chain-smoking cigarettes and pipes. He died in Samoa in 1894 at the age of forty-four. His kindness to the indigenous people there had earned him the name Tusitala, Samoan for "Teller of Tales." On his death, a delegation of Samoan people watched with his body through the night and buried him on a plot overlooking the sea.

In California, archaeology, preservation and research continue at the missions and adobes, and their histories continue to be controversial. Yet more than a century after Stevenson's death, the old missions and the Spanish and Mexican adobes throughout the state serve to help researchers and students better understand how complex cultures clashed and connected in California in the eighteenth and nineteenth centuries. The old adobe Stevenson stayed in during his visit to Monterey, built during the Mexican era, has been preserved as the Robert Louis Stevenson House, a California state park.

Stevenson's story is further evidence individuals can have a big impact on history. From people of many cultures building cathedrals in the wilderness to rail-thin bachelors chasing married ladies across continents (and pausing to notice history along the way), change and adventure have long been fixtures of the California landscape.

Robert Louis Stevenson thrived on both. His vision soared in the California sunshine.

4

SARAH WINCHESTER

THE VISION TO BE DIFFERENT

Her mammoth house on the open landscape of the valley floor was a statement of some kind, and a steady stream of Sunday drivers passed Llanada Villa as out-of-town guests were treated to the spectacle out on the dusty country road. Sarah Winchester's house served as a tourist attraction long before its doors were officially opened for a fee.
—*Mary Jo Ignoffo*

If you are a person fascinated by enormous houses, you will find quite a few large enough to inspire awe. In France, there is, for example, the Palace of Versailles. With more than 721,000 square feet of living space, Versailles is one of the largest houses in the world. King Louis XVI and Marie Antoinette lived there for a while. Later, they had no need of it, having lost their heads in the French Revolution.

Winston Churchill, not a royal personage but a great one, was born at Blenheim Palace in England, another whopper, which belonged to the seventh Duke of Marlborough, his grandfather. Visitors to this stately home in Oxfordshire can stroll its hundreds of rooms and more than a million square feet of living space. The ninth duke even married American Consuelo Vanderbilt in 1895 so her family fortune could help restore it, something Consuelo said it desperately needed since there wasn't a comfortable room in the whole place.

Crossing the pond, the house-loving traveler might stop by the Biltmore Estate near Asheville, North Carolina, built by another Vanderbilt between

1889 and 1895. It interiors encompass 178,926 square feet and include 250 rooms, or about four acres of floor space. The forests planted on the property are so large Gifford Pinchot once managed them—and he was the first chief of the U.S. Forest Service.

Hearst Castle near Cambria, California, also is pretty roomy. A visitor can spend several days taking in the various tours of the estate, now a California state park. Publisher William Randolph Hearst had workers there from 1919 through 1947 to construct a casa and guest cottages that contain ninety thousand square feet of antique-strewn, knickknack-cluttered living space. The main house, at sixty thousand square feet, is slightly larger than the White House.

Which leads one to wonder about the fantastic mythology that has grown up to surround the gabled home at 525 South Winchester Boulevard in San Jose, California, known as the Winchester Mystery House. Its builder, the diminutive heiress Sarah Winchester, created a house in the Santa Clara Valley between 1886 and her death that encompassed twenty-four thousand square feet, 161 rooms and 47 fireplaces. It is a good-sized house, but it is relatively small when compared with so many others built around the world over the centuries.

The house is interesting. The true story of the woman who built it is even more so.

Unverifiable tales connecting Sarah Winchester and the house to séances and the occult are major reasons for its fame. You can still check out books from your local library about Mrs. Winchester with passages like this: "According to what the little widow knew of *ghosts*, these 'specters' enjoyed disappearing up chimneys.…For their convenience she built 47 fireplaces, so when it was time for them to go or come, there would be no congestion."[1] Why a spirit without a body would need to use a chimney to go in and out of a building is not explained.

In the twenty-first century, marketing at the historic house repeats the tales of a spiritualist's séance, a Winchester curse and a promise that Sarah would live "as long as she kept building."[2] This spooky element has fed the legend.

"The pull, the draw, the magnetism of the Winchester House is substantially prodded along by nearly ninety years of advertising," writes historian Mary Jo Ignoffo, author of *Captive of the Labyrinth*, a thorough, well-researched biography of Sarah Winchester—one of the rare few. "The bottom line that promoters through the years have understood very, very well is that no one can resist a good ghost story."[3] British broadcaster Laura Trevelyan, who

Mrs. Winchester traveled the world before she moved to California and saw many large country homes and castles. Her experiments in architecture on her San Jose home are not unusual when seen in that context. In the middle of the rural Santa Clara Valley, however, her house did stand out. *Author's collection.*

has also written about the Winchesters and is related to them through her American grandmother, said: "Sarah was a rather more nuanced character than her Mystery House caricature suggests."[4]

Local historian Ralph Rambo, who died in 1990, remembered Mrs. Winchester from his childhood. His uncle Edward "Ned" Rambo headed the office of the Winchester Repeating Arms Company in San Francisco and helped Sarah Winchester manage her Santa Clara Valley estate. As he recalled in 1967, "She was a highly sensitive lady and the cruel rumors even then in circulation disturbed and hurt her. Eventually all this idle gossip reached her ears and as it persisted she withdrew closer into her multi-storied shell."[5]

Sarah Winchester's strange fame is focused on her life in California, but her story did not begin in the West. She was a native of New Haven, Connecticut, the small New England town that grew quickly during the Industrial Revolution and is home to Yale University. Born in 1839 into the family of Leonard and Sarah Pardee, she was one of five sisters and a brother.

Her father was a craftsman who ran a woodworking business adjacent to the family home in New Haven. "The comings and goings of wood

Both Sarah Winchester's family and her husband's family prospered in New Haven, Connecticut, the home of Yale University. After Sarah Winchester left quiet New Haven for distant California, she did not move back. *Author's collection.*

craftsmen were simply a part of life for them there, making up a lifestyle that Sara replicated years later in California," writes Winchester biographer Ignoffo.[6]

Leonard Pardee's success ensured he could afford private lessons for his daughters, giving them a better opportunity to enrich their lives with learning. The Pardees were not, as far as anyone can tell, a family with a trendy belief in spiritualists or séances. They were ardent abolitionists who attended the First Baptist Church of New Haven with their neighbors the Winchesters.

Sarah thus knew William Wirt Winchester from her childhood. His father, Oliver Winchester was, like Sarah's father, a self-made man. He created his first fortune designing and producing a shirt with a better fit than others on the market, a design that earned him a patent in 1848. He further innovated by turning out his shirts by mass production, using treadle sewing machines operated by factory workers to create a sartorial assembly line at his Winchester and Davis Shirt Manufactory. Many of these early machines of the Industrial Revolution were powered by leather belts made from the hides of California cattle.

Winchester's purchase in 1855 of stock in a small startup called the Volcanic Repeating Arms Company appears to have been not much more, at the beginning, than an investment of capital. The two men involved in Volcanic—Horace Smith and Daniel Wesson, who went on to greater fame for their handguns—had been awarded a patent for a repeating weapon. It was a timely idea in a world dominated for centuries by single-shot weapons. The repeater could be fired more than once without having to be reloaded. "From his work on the perfect dress shirt, Oliver knew about the value of patents, and he liked the look of Volcanic's talent and backers."[7] When the company failed, Winchester bought its assets and convinced several other investors to join him in a new venture, the New Haven Arms Company, which he hoped would improve upon the weapon's manufacture, design and sales. Winchester and his company hired Benjamin Henry, who used the concept of the repeater in his design of a new rifle.

By the time Sarah Pardee and William Winchester married in 1862, America was in the middle of the Civil War. Though the New Haven Arms Company was never able to secure the big contracts from the Union army as Oliver Winchester had hoped, the war itself was a great and terrible proving ground for new weaponry. Benjamin Henry improved the Volcanic's design, and Winchester's Henry rifle gained fame in the war with soldiers who carried it. Battle-tested men spoke of the lifesaving value of having a weapon they didn't need to stop and reload every time they wanted to shoot.

When the Civil War ended, settlement boomed in the American West. Homesteaders living on scattered farms and ranches discovered they needed weapons as tools in their daily lives. They found the repeating rifle handy for hunting, protection from lawlessness, controlling cattle on the range and defending themselves from wild animals, increasingly startled by the presence of so many humans in their territory. Both Indian raiders and the U.S. Cavalry stockpiled repeaters as they faced off on the Plains. Winchester, who had sold only about 10,000 repeating rifles between 1862 and 1865 sold more than 100,000 of his Model 1866 rifle as the firm transformed itself into the Winchester Repeating Arms Company. Long before the company adopted its slogan, "The Gun that Won the West," many Americans believed this very thing about the Winchester.[8] Beginning with an investment of $40,000, the company grew to be worth millions.

When Sarah and William married, he was an executive with his father's shirt company. Just a few years later, he was named secretary of Winchester Repeating Arms and then vice president of its rifle division. "He never exuded

the enthusiasm for the arms industry that his father did, but he followed in his father's footsteps nevertheless."[9]

The marriage seems to have been a loving partnership between two quiet people. Sarah was tiny, reportedly just four foot, ten inches tall and barely one hundred pounds.[10] William was slender and about a foot taller than Sarah. In spite of the rapid growth of the Winchester fortune, the couple continued to live with his parents and did so during their entire marriage.

In 1866, the couple had a daughter, Annie. She barely survived a month. Though devastating, the death of an infant was not unusual in the eastern United States in the nineteenth century. Sarah's parents lost an infant daughter in 1832, and William lost a baby brother in 1845. The fact that William and Sarah spent the year following their daughter's death withdrawn from the

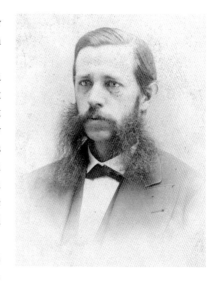

William Wirt Winchester was born in 1837 and died of tuberculosis in March 1881. This photograph was taken at the studios of Bundy & Stoddard in New Haven, a business that appears only in the city's 1881 directory, so it is likely this photograph was taken during the last year of Winchester's life. *Courtesy of History San Jose.*

public eye also was not unusual: a year of mourning was accepted as the proper social behavior of the day.

The stories told today about Sarah make it appear she suffered the loss of both her child and her husband in quick succession. But that's not true. Though there would be no other children, the couple shared a storehouse of positive experiences in the coming years. First, they helped his busy parents supervise construction of a new family home. Sarah learned she was interested in architecture and interior design during the project. And she discovered she liked working. "In the years to come, she would often turn to the curative powers of work to restore physical and emotional well being."[11]

The couple traveled to Europe and the Middle East on Winchester company business. They were also sent out to California by Oliver Winchester to inspect a new company office in San Francisco and made the journey in the early 1870s, when the first transcontinental railroad was just a few years old—in fact, just ahead of Robert Louis Stevenson, who made the train trip across American in 1879. In San Francisco, they inspected

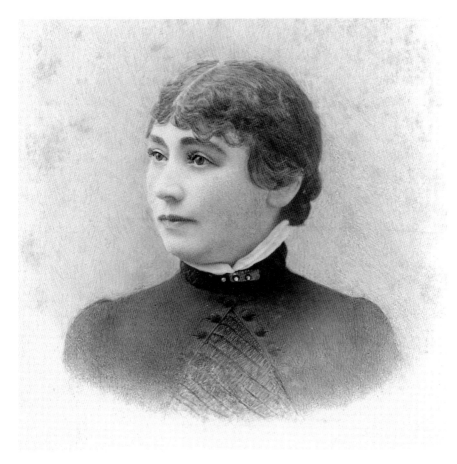

Sarah Winchester first came to California on the transcontinental railroad in the early 1870s with her husband, William and had her photograph taken by Isaiah Taber in his studio at 121 Post Street. It is a rare portrait of a young Sarah Winchester. *Courtesy History San Jose.*

the Winchester offices at 108 Battery Street and saw San Francisco just as it was beginning to grow out of its days as a rough-and-tumble Gold Rush city. While she was there, she had a photographic portrait taken by San Francisco's I.W. Taber.

Sarah's father died in 1869. Her mother died in 1880, a year that brought great loss into Sarah's life. With her mother gone in May, there was more grief in December, when her father-in-law, Oliver Winchester, died of a stroke. The company's board of directors hoped to nominate William to serve as president, but he was already suffering from the advanced stages of

tuberculosis and took leave and moved to New York, seeking treatment and legal advice on his will. As the *New York Times* reported, "On Saturday last he returned to New Haven, remarking to the conductor of the train, in passing the usual compliments of old acquaintanceship, that he was taking his last trip. He lingered until Monday evening."[12] William Wirt Winchester died a few months shy of his forty-fourth birthday.

Sarah had inherited a comfortable legacy from her parents. Now, in her bereavement, she inherited another from her husband with a great deal more to come upon the death of her mother-in-law. The myths suggest she fled from New Haven to California, but after William's death, Sarah took no definitive action. She spent time at the seashore and lived in Europe for several years. It wasn't until she learned of the terminal illness of her eldest sister Mary Converse, three years after William's death, that Sarah returned to New Haven and began to turn her eyes to California. One historian noted Sarah had earlier hoped to bring her husband to California for his health, so the West may have been on her mind for some time.[13] Since Sarah was now suffering from arthritis, a doctor advised her she might do well to find a warmer climate and an interesting hobby to improve her life.[14]

Mills College was established as the Young Ladies Seminary in Benicia in 1852, and after moving to Oakland and changing its name, it became the first women's college west of the Rockies. Sarah Winchester's brother-in-law served briefly as president of Mills. *Author's collection.*

During the winter of 1885–86 she traveled to California for the second time. This time, it was to stay with her sister Antoinette, known as Nettie, who was married to Civil War veteran and lecturer Homer Sprague. Sprague had been appointed to serve as president of Mills College in Oakland, and the couple lived in a house in the hills that overlooked San Francisco Bay. Sprague was a bumptious character, and it became clear early on his tenure at Mills would not last long. But Sarah was already formulating a plan of her own.

Ned Rambo, of the San Francisco Winchester office, told Sarah about the beauty of the Santa Clara Valley, thirty miles south of the city and away from its fog. He had recently bought a small ranch there for his family and thought she, too, might appreciate this sunny landscape. It was Ned Rambo, not a spiritualist, who led Sarah to what would become her famous home. "Ned Rambo proved a valuable guide as she said goodbye to the Spragues and boldly embraced California."[15]

She found a ranch for sale on land in the valley now part of San Jose. Then, it was outside city limits in a paradise of rural fields covered in wild mustard, range land and commercial orchards. The forty-five-acre property on the Santa Clara–Los Gatos Road included a small farmhouse, and she purchased it from John Hamm for $12,570.

She was forty-seven years old. For all her wealth and position, it was the first house she had ever owned.

Sarah Winchester had spent the first five decades of her life as a daughter, sister, wife, aunt and daughter-in-law—a woman more acted upon than acting. In California, she transformed herself. The first symbol of the metamorphosis was the humble ranch, which she renamed Llanada Villa because the setting reminded her of a Basque plain she had once seen near the Pyrenees. She began to remake the place to suit its romantic name.

"Mrs. Sarah Winchester's arrival was a sensational event," recalled Ralph Rambo. "Our valley was thrilled by this dramatic entrance of a millionairess; by those freight cars sidetracked in Santa Clara, unloading rich imported furnishings; by building activity that mushroomed an eight-room house into a twenty-six-room mansion the first six months."[16]

In remodeling the house, Sarah began to rebuild her life. For the first time, she took active control of her finances, which had been managed by her brothers-in-law in New Haven. Now, in addition to hiring Ned Rambo to advise her, she hired San Jose attorney Samuel Franklin "Frank" Leib to handle her legal and financial affairs. Leib was a well-respected former judge who also advised Mrs. Leland Stanford. He was not averse

THE MYSTERY HOUSE
BEFORE IT GREW

This photo is believed
to show the original
Winchester house in about
1890. Archivists believe
the woman barely visible
on the bench at right is
Sarah Winchester. The
woman on the horse is
likely her niece Daisy
Merriman. The photo,
recently discovered in
the archives of History
San Jose, probably shows
the house after its first
remodel. *Courtesy of History
San Jose.*

to eccentrics, counting Luther Burbank—the man who invented both the plumcot and the white blackberry—among his friends. According to one observer, "Despite her eccentricity Mrs. Winchester had a reputation for shrewdness in business affairs."[17]

Sarah took charge as head of her immediate family. She convinced her sisters Isabelle "Belle" Merriman and Estelle Gerard to join her in California. With Nettie's return to the East—after Sprague parted from Mills College—and Estelle's death in 1894, Sarah and Belle became increasingly close. Sarah supported Belle's daughter Marion "Daisy" Merriman, who moved in with her at Llanada Villa, acting as a companion and secretary until the younger woman's marriage in 1903.

Sarah's move to the Santa Clara Valley came in the early years of its transition from rangeland to orchards. In 1870, there was just one rudimentary cannery in the valley—by 1922, there would be forty.[18] In 1886, Sarah Winchester became a valley innovator when she planted acres of her property in apricots and prunes, making her "among the earliest settlers coming to the valley to grow fruit."[19] Her orchards joined a growing industry that provided work for thousands, fed many more around the world and made profits that could be reinvested in the valley. In 1887, as growers planted a quarter of a million fruit trees in the Santa Clara Valley, Sarah built houses on her property for workers and staff, making life better for them and their families. She continued buying land surrounding her San Jose estate until her holdings there approached 160 acres.

And she didn't confine her investments to Santa Clara County. She bought an estate in Atherton—San Mateo County—and then another nearby for her newlywed niece Daisy. She eventually owned forty-five Atherton acres, including a Mission Revival mansion where she spent a great deal of her time after the turn of the twentieth century. When Daisy and her husband, Fred Marriott, decided Atherton didn't suit them, Sarah bought them another house in Palo Alto on Waverly Street.

She bought more than a hundred acres in Burlingame and commissioned a three-bedroom houseboat to moor there, a domicile she fully staffed and to which she retreated during the hot summer months.

In 1888, she bought a ranch outside Mountain View so her sister Belle and her brother-in-law Louis Merriman could tend a vineyard, raise flowers and breed carriage horses there. The sisters named the house El Sueño—which they translated as "the daydream"—and began yet another remodeling project, turning a four-room cottage into a two-story home.

This photo of Sarah Winchester was long publicized as "the only photo ever taken of the mysterious Mrs. Winchester." Winchester's friends said there was no mystery—she just didn't like the way she looked as she got older and that's why she avoided the camera. *Courtesy of History San Jose.*

A twentieth-century photo of the now-extensive Winchester house shows the multi-storied home in the background as apricots dry in the sunshine on trays in the foreground. *Courtesy of History San Jose.*

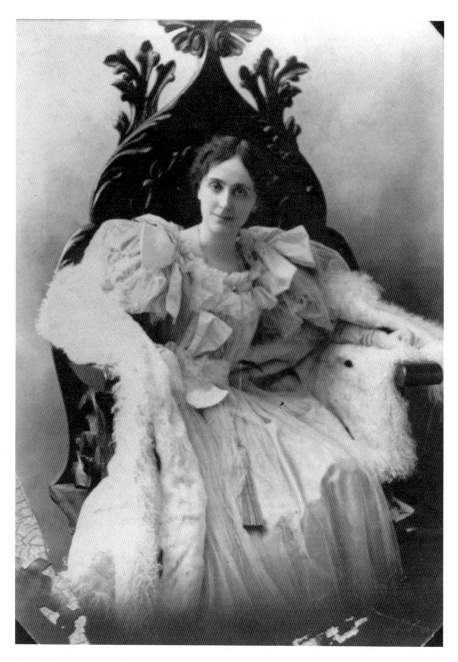

Daisy Merriman was a favorite niece of Sarah Winchester's and here poses on an ornate chair that looks like something her aunt might own. The photograph was donated to San Mateo County by researcher Burton Klose about 1982. *Courtesy of the San Mateo County Historical Association Archives.*

Between 1904 and 1905, Winchester learned Southern Pacific planned to bisect the Merriman ranch with a new rail line along the peninsula. This, she believed, would devalue her property, since it would make it difficult for the horses on the ranch to move from their pasture—roughly the site of today's downtown Los Altos—across the tracks to their watering hole at Adobe Creek. While Winchester fought Southern Pacific, stories circulated that she and her sister were going out at night, pulling up the railroad's surveying stakes. Since Sarah Winchester was not a regular resident of the ranch and was by then suffering from rheumatoid arthritis, it unlikely she did this. The railroad, however, did file a restraining order against her sister.

"Mrs. Winchester often cooperated in real estate deals or issues of eminent domain," writes historian Mary Jo Ignoffo. "But she objected when she believed she was being bullied or swindled. She believed SP could have skirted her property and left a perfectly good horse ranch intact."[20]

In the end, Sarah Winchester lost her fight, yet won a major point. She insisted, since the railroad was damaging her ranch, it must either buy the entire 140 acres or face further action. Southern Pacific gave in and figured out a way to placate her, buying the land and flipping the surplus to SP executive Paul Shoup, who, with developer Walter Clark, subdivided it for building sites, creating the new town of Los Altos, now conveniently located along a handy SP line.[21] Sarah built another home for Belle, this one in Palo Alto. The original Winchester-Merriman ranch house still stands, the oldest house in Los Altos and a city landmark.

Sarah Winchester accomplished so much in this second act of her life it is not impossible to imagine her energy and vision inspiring gossip and envy. Yet in spite of that, she took time out to help her neighbors. She bought clothes for those in need and delivered them herself to a Cupertino church. She invited her neighbors' children in for ice cream. A boy who delivered her newspapers recalled: "I will always remember her giving me the complete story of the life of a robin....It made such an impression upon me that never again did I ever shoot at any song bird."[22]

It is true she built and built and built at Llanada Villa until it contained cupolas and gables and elevators and porches and chimneys and thousands of windows that illuminated hundreds of rooms. She built up, pulled down and built some more. Why she did it, only she could say. And she didn't say. But she did not build without ceasing. Mary Jo Ignoffo discovered an 1898 letter Sarah wrote to her sister-in-law: "[T]hen I became rather worn and tired out and dismissed all the workmen to take such rest as I might through the winter. This spring I recalled the carpenters, hoping to get my

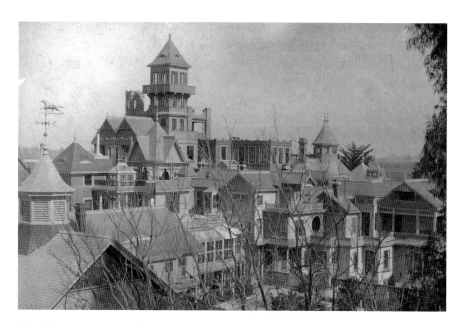

The Winchester mansion before the 1906 earthquake in a photo taken from a water tower behind the house. It is interesting to speculate how the heavy camera equipment of that era was hauled up and successfully used in that location. *Courtesy of History San Jose.*

hall finished up."[23] This is clear evidence Sarah Winchester was not afraid to stop building.

She remained an enigma because she never—that we know of—spoke to a reporter. All who wrote about her during her lifetime dealt in speculation. At least one reporter for a San Jose newspaper may have hit closest to the mark in 1911 when she wrote:

> *Perhaps not more than a dozen people in California know that Mrs. Winchester is a musician with a genius for composition, that she is a remarkable businesswoman…that her famous house of mystery at Campbell is merely a workshop and the structure itself is merely a collection of notes taken by a woman of great wealth while educating herself in the architecture of several countries.*[24]

She did love new ideas. At Llanada Villa, she installed an early intercom system and insulation long before either of these things were common. She designed a window latch based on the Winchester trip hammer. She recycled water for use on her houseplants and installed "a thousand things

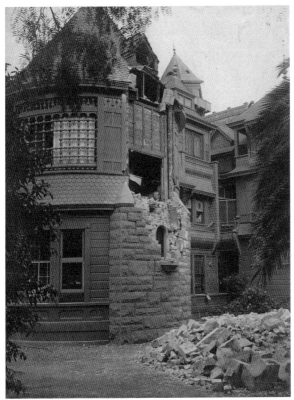

Above: Mrs. Winchester was a creative thinker who worked closely with her staff to implement her ideas. This window latch at her home is based on the trip hammer of the famous Winchester rifle. *Courtesy of History San Jose.*

Left: The San Francisco earthquake of 1906 did extensive damage to the Winchester mansion. Mrs. Winchester decided to sweep up the damage and leave the house as it was, though she admitted to relatives it did make the house look odd. *Courtesy of History San Jose.*

of beauty to see, as well as practical household innovations years ahead of their time."[25] She invented a staircase of small steps to make going upstairs easier on her arthritis.

The 1906 earthquake was a setback. Her mansion was in shambles. The largest recorded earthquake in modern California history collapsed upper stories at the Winchester house onto lower ones, destroying a tower, balconies and porches. Now approaching seventy, Sarah made the decision to clear away the rubble and leave some of the damaged rooms just as they were—turning an unusual house into a genuine oddity. Her niece Daisy's husband, Fred Marriott, said even Sarah thought the house now really did look "as though it had been built by a crazy person."[26]

She spent several years after the quake working on her Burlingame property, believing the bay front there would make a great harbor. It was a visionary concept, but about half a century ahead of its time, for a different mode of transportation she could not possibly foresee. The land she owned on San Francisco Bay would indeed become part of a great port of sorts one day: much of it has been incorporated into San Francisco International Airport.

As Sarah lay dying in Atherton, she had her staff move her to the first home she had ever owned—her house in San Jose, where she passed away on September 5, 1922, at the age of eighty-three. Though financial difficulties at the Winchester Company had reduced her fortune by nearly two-thirds, she died leaving an estate worth at least $3 million, an enormous sum then. For a woman legend said hoped never to die, she left a complex will benefitting more than a dozen heirs, from her beloved Japanese gardener to a hospital in Connecticut honoring her late husband.

And Connecticut is where she might have lived out her life had she not been the unique character she was. Born into a time when woman could not vote, she voted with her feet, leaving the staid East Coast behind for a land where freedom of expression seemed to be in the atmosphere—along with the sunshine and the fog. In California, she found fewer rules for proscribed behavior and lived a life of accomplishment—measured strictly on her own terms.

Millions of people have been drawn to visit her house in San Jose. Is it any wonder? If people did not want to know more about this unique woman through the quirky mansion she designed, built and loved—that would indeed have been a mystery.

5

THOMAS FOON CHEW

THE VISION OF THE ENTREPRENEUR

His progressive ideas, intuition, and good decisions
made Bayside the nation's third largest cannery.
—*Robert Burrill and Lynn Rogers*

The San Francisco earthquake and fire of 1906 are still among the worst disasters ever visited upon California. But there is a reason for the ancient myth of the phoenix rising from the ashes of a terrible flame. Some things are regenerated after a fire.

Amid all the sorrow and loss, pain and disruption, immigrants from China—and would-be immigrants as well—discovered the disaster brought about an interesting change in their lives. They faced terrible trials coming to the United States, and many were marginalized and sometimes violently abused after they arrived. But conditions in the Canton region and in Shanghai, from which many of the Chinese came, were so bad even these issues did not stop thousands from coming. "When inflation, political and economic instability, drought and famine struck the region, emigration to the western world became an important safety valve," noted Connie Young Yu of the Chinese Historical and Cultural Project of Santa Clara County. Her ancestors were among the many who braved the journey to establish successful lives in California.[1]

The disaster of 1906 in San Francisco is important because San Francisco was the main port of entry for Pacific immigrants and the home of the West's largest Chinatown. In the earthquake and fire, Chinatown burned

to work at almost any job and for lower wages than other workers, and that created serious issues for many of the Chinese workers.

The California legislature and some local governments tried passing taxes, fees and other laws specifically targeted at the Chinese. Many of these efforts proved to be illegal. "Because anti-Chinese discrimination and efforts to stop Chinese immigration violated the 1868 Burlingame-Seward Treaty with China, the federal government was able to negate much of this legislation," according to the U.S. State Department.[13] In addition, Chinese leaders and businessmen organized. In the 1860s, a group of Chinese associations joined together as the Chinese Six Companies to fight discriminatory legislation throughout California and to advocate on behalf of Chinese workers and businesses. The Chinese Six Companies are still active today.

There were conflicting views among Californians. Some businessmen refused to support laws limiting Chinese immigration because they needed the workers. Merchants saw the Chinese as good customers, according to historian Ping Chiu. "Their habits of paying cash and honoring debts contributed in no small measure to the welfare of the mercantile community during a period of violent and frequent business fluctuations."[14]

But in 1882, the U.S. Congress passed the Chinese Exclusion Act, prohibiting Chinese immigration for ten years. It was the first act in American history to place broad restrictions on immigration and the only one that specifically targeted a single national group.[15] It prevented Chinese immigrants from becoming naturalized citizens, among other restrictions, and was extended in 1892 and again in 1902. Over the years, a number of amendments were added, including provisions allowing family members of legal immigrants to join them. Exceptions were also made for merchants and their families.[16]

How Sai Yen Chew was able to bring his son Thomas Foon to America during this difficult period is not known. He may have immigrated before 1882, gained legal status and then returned to collect his family. But it was very unusual that he appeared in America with a wife and son after the Chinese Exclusion Act went into effect and had no other children at a time when Chinese families were almost always large. A granddaughter was told Thomas was born in 1887 in the Loong Kai District of Guangdong Province and his father brought him to San Francisco about 1897.[17] Thomas's youngest son, Timothy, agreed, telling an interviewer: "Born in China and brought to this country by his father at a very early age, he had to overcome the first obstacle of getting an education."[18] A 1931 article in the *San Jose Mercury Herald* describes Foon as "a native of San Francisco," but the

newspaper reporter may have meant only that San Francisco was Thomas Foon's American hometown.[19]

Yen Chew's great-granddaughter recalls discussions with her grandmother that have led her believe the U.S. border was fairly porous in those days in spite of the law: "People who had the money could always go back and forth without any trouble."[20]

A great deal about the family's early life in San Francisco is not known. We do know Yen Chew's first business was called Precita Canning, and it was founded about 1890. The plant was located near Broadway and Sansome on the edge of the old Chinatown.[21] Family members say it was small, producing no more than 100,000 cases a year. The challenge of gathering information about Yen Chew and Precita Canning is obscured by another factor: "[M]any of the first generation Chinese immigrants were reluctant and adverse to relaying any information that may be printed. A general consensus, springing from a cultural tradition, is that the less known about an entity the better."[22]

The Foon family prospered, and their two automobiles are evidence of that in an era when few valley residents owned even one car. Mrs. Chew is at left with her children around her. It must have been a big day, since her eldest son, Charles, is wearing a boutonniere. *Courtesy of Gloria Hom.*

After the disaster of 1906 destroyed the factory in San Francisco, Yen Chew moved the family and the business to Alviso in Santa Clara County. Land was cheaper in Alviso, the weather was better and there was much more room for a business to grow. The community then was partly industrial and partly rural, and Chew may have felt he would face less discrimination there.

Also attractive: Alviso's assets as a port city. The Guadalupe River and Coyote Creek empty into San Francisco Bay at Alviso and at that time, Alviso was a booming port and the main one used for shipping products from Santa Clara County to San Francisco. Canned goods and produce are heavy cargo and can be expensive to transport. Shipping on the water was economical at a time when the railroads had a monopoly and rates were high, urban and rural roads were bad and the use of trucks for long-distance hauling was not yet widespread.

At some point, after Yen Chew moved the canning company to Alviso, he brought his son, Thomas Foon Chew—often called Thomas Foon—into the business and renamed the company Bayside. Even then it was small. "Chew was launched into business by his father, Yen Chew, who operated the Bayside Canning company near Alviso," reported one San Jose newspaper. "In 1906, when the son entered the business the cannery operated only on tomatoes, and was equipped with only one 40-horsepower boiler."[23] The name *Bayside* is identified in several ways in that era: a cannery label shows it spelled BaySide, a sign on the cannery's building shows it spelled Bay Side and contemporary articles usually identify the company as Bayside.[24]

Tom Foon and his family had already faced all kinds of challenges in the United States, beginning with school, since many public schools in California then excluded Chinese students.[25] Foon attended a Chinese school in San Francisco. "Since Tom Foon's family lived in Alviso, it is believed that he lived with relatives in San Francisco while attending this school."[26] San Francisco had been Tom Foon's first American home, so attending school there would have placed him in familiar neighborhoods—though difficulties remained. "One of Tom Foon's life-long friends whom he met at this school lived in South San Francisco and had to take a horse drawn streetcar five miles one way every day to attend school."[27]

In 1907, when Foon was about twenty years old, his family arranged for him to marry a wealthy young woman named Lee Gum Ching, born in Oakland about 1889. Though American by birth, she came from a family so traditional, they bound her feet when she was young. "She always had

Left: Mrs. Thomas Foon Chew was born Lee Gum Ching, in Oakland, into a wealthy family. She told her grandchildren she traveled back to China nine times—always going first class on the best ocean liners—to find a bride for her son Charles. *Courtesy of Gloria Hom.*

Below: The Bayside Cannery in Mayfield – now Palo Alto—in 1918. There were fewer Chinese workers at the Mayfield plant. The sign on the door reads: "Notice! Positively No Admittance except on Business." *Courtesy of the Palo Alto Historical Association.*

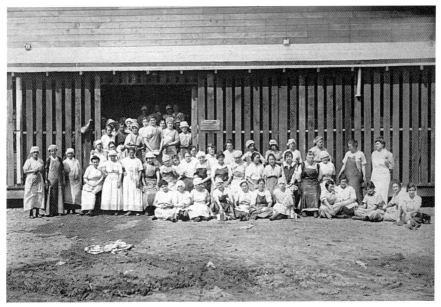

trouble walking, later in life," said one granddaughter.[28] "By 1908," said another family member, "she was seventeen years old, married, and had her first child." The couple would have nine children together, with seven surviving to adulthood.

Though we have no photographs of Yen Chew and know very little about him, newspaper reports about his son say Yen Chew operated a conservative business. Thomas Foon, raised in entrepreneurial California, brought change to his father's canning company, as he "pioneered many innovative factory methods" according to historian Connie Young Yu.[29] Early on, Foon began to make improvements to speed production. He devised a machine that washed tomato boxes on an assembly line and flipped them over at the end of the line for easy stacking. His five trucks provided another opportunity. Some of his workers lived in Sunnyvale, Mountain View, Santa Clara and Milpitas, and that meant a commute to Alviso—difficult for hourly workers of limited means. Foon found a way to use his trucks as buses in the morning to deliver workers to the plant, after which covers and seats were removed and the trucks were converted for hauling. In the evenings, after their last load was hauled, the trucks were converted again so they could transport the workers home. "Progressive ideas of the young Chinese resulted in rapid growth," said a local reporter.[30]

Foon was both kind to his workers and practical. Discrimination meant housing could be difficult for immigrants. "[He] built warehouses and boardinghouses for 100 Chinese laborers, where a room and three meals a day cost $2.50 a week during fruit-canning season."[31] His canneries had company kitchens where workers could buy a hot lunch for ten cents. Beyond the work season, Foon made a point of tending to the workers' welfare. "Between canning seasons he would permit them to stay in the cabins near the cannery and saw to it that they had enough to eat,"[32] a friend said many years later.

He expanded the business with additional plants in Isleton on the Sacramento River and Mayfield in Palo Alto, also buying an interest in the Field and Gross fish cannery in Monterey—where the Chinese had moved into the fishing business after the Gold Rush. Continually looking for better supply and more opportunity, he planted peaches on land he purchased near Yuba City and sowed rice on several hundred acres more in Merced County.

Mayfield and Alviso packed and canned apricots, pears, peaches and tomatoes. Gloria Hom said Foon was so charismatic, when the waters of the

Thomas Foon was about seventeen years old when he joined his father at the Bayside operations in Alviso. This photo of him at a Bayside loading dock shows him as the tall and dapper boss. *Courtesy of Gloria Hom.*

bay would breach the dikes in Alviso and flood the cannery, he cheered on his workers as they continued toiling away in several feet of water.

The Isleton plant packed asparagus, and it was for his canned green asparagus that Tom Foon and Bayside found fame. Until Foon and an inventive employee named William de Back solved the problem about 1920, green asparagus was not canned because the delicate vegetable was unable, in most cases, to survive processing without the fragile stalks breaking or turning to mush. Besides developing a system of careful sorting and trimming to limit damage, one of their best innovations was to use square cans, which kept the asparagus "from rotating in the cans and breaking the tips."[33] Newspaper reporters nicknamed Tom Foon "The Asparagus King."

Like all entrepreneurs, he faced challenges. He bought a tugboat and a barge to haul produce and equipment between the docks in Isleton and Alviso. The tugboat had a visionary name—the *Progress*—but had a decidedly ignominious end. Its engine stalled near Rio Vista on the Sacramento River, and attempts to restart it led to an explosion, which sank the boat to the

Two canning labels from Northern California with racist slogans testify to the challenges Tom Foon faced in his business. The late Ralph Rambo was a label designer who donated these from his collection to the archives of History San Jose. *Courtesy of History San Jose.*

bottom of the river. Former Bayside worker Tony Soares told an interviewer that though nobody was injured in the accident: "It is believed that part of the hull of the *Progress* is still there where she went down."[34]

Not all of his difficulties were mechanical. Though he was the first Chinese in the Santa Clara Valley to join the Masons and also was a Shriner in San Jose, barriers remained. "It was an uphill pull for Chinese to become respected by the 'white' community for anything other than laundry operators or domestic servants," one writer said later.[35] There is graphic evidence of this.

Ralph Rambo, nephew of Sarah Winchester's first ranch manager Ned Rambo, spent half a century as an artist at Muirson Label Company producing canning and packing labels in the valley. Before his death in 1990, he donated a box of labels to History San Jose, and two of them are illustrative. One, for Our Choice Tomatoes, packed in San Francisco, has this slogan on its label: "White Labor Exclusively Employed at This

Factory." Another, for Magnolia Brand Strawberries of Healdsburg, has something similar: "White Labor Exclusively Employed in this Cannery." This was the environment in which Tom Foon worked.

In spite of it, "He just didn't allow himself to be segregated," said Gloria Hom. He became enormously successful, and his success helped break down barriers. By the 1920s, he had built Bayside into the third-largest canning company in the United States. Only Del Monte and Libby were more profitable.[36] To find staff, he hired mostly Chinese workers at first but also hired Japanese, Filipino and European immigrants. The diversity was not without its problems. "In the summer of 1908, a particularly robust harvest season in which growers faced a scarcity of help, all the cannery's white employees went on strike." The white workers said they were being unfairly treated by Asians.[37] Foon managed to mediate the crisis.

It helped that he trained and promoted loyal staff from within. William Hee told an interviewer in the 1970s he went to work for Yen Chew when he was sixteen and, though he had only a grammar school education, was later promoted to canning superintendent at the Alviso plant. He believed he owed everything he was to Tom Foon and Yen Chew. In the 1920s, as many second-and third-generation Chinese entered professions, fewer were interested in hourly jobs. Foon turned to other immigrant groups for staffing, employing them primarily at his Mayfield plant, since fewer Chinese lived in the Palo Alto area.

He worked hard and faced chronic stress in an industry known for its volatility. Big crops one year would drive up supply and drive down prices, and the next year everything might be the other way around. Perhaps it is not surprising a compulsive worker like Tom Foon would have health issues. "He had long been a sufferer from asthma,"[38] reported the local paper. Asthma is a disease exacerbated by anxiety and stress, as David McCullough documents in *Mornings on Horseback*, his award-winning biography of Theodore Roosevelt, who also suffered from the disease. Foon and his family bought a house in Los Gatos, known in those days for the clearness of its air, and Foon said it was "the ideal place to get a good night's rest. He spent as much time as possible in his home there, although most of his time was devoted to his business."[39] If Foon was too busy to gain much benefit, his family thrived. In 1930, his daughter May Lan Chew, nicknamed Lonnie, became the first Chinese woman to graduate from Los Gatos High School.[40]

In 1929, he held a costly three-day wedding celebration for his eldest son, Charles, a man family members describe as a "character," who later ran

	PIE	#1 F. STD.	#2 CH.
		#1 F.	#2
	PIE	STD.	CH.
Green Fruit	71	91	79
Labor	1.103	1.085	75
Sugar		347	378
Cans	411	114	608
Shook & Nails	174	19	15
Labels	017	13	07
Total	2.415	2.776	2.746
Factory Exp.	070	070	070
Freight In	012	012	012
Buying Exp.	012	012	012
Fuel Oil	03	03	03
Lease Rental	012	012	012
Power	016	016	016
WHSE. Exp.	026	026	026
Indirect Labor	097	097	097
Auto Operation	074	072	050
Repairs	056	054	038
Dep.	16	16	11
Ex. Salary	026	026	026
General Exp.	027	027	027
Office Salary	06	06	06
Taxes	007	007	007
Insurance	023	023	016
Interest	05	05	035
Brokerage	32	38	22
Freight Out	05	06	045
Grand Total	$3.543	$3.97	$3.655
Sales Price	2.37½	4.56	3.40

APRICOTS ALVISO
1924 $50. TO $60. PER TON

Thomas Foon's 1924 notebook shows it was a challenge for him to make a profit on his apricots that year. Costs in the first category, per ton, were $3.54, with the price at just $2.37. The last category also projects a loss. Only on the apricots in the most expensive category—the middle row—was he able to make a profit. *Photo by the author.*

several gambling operations in the Santa Clara Valley. The wedding event made headlines in San Francisco and San Jose and included banquets in both cities, with each one attracting a guest list of five hundred, including the Chinese consul general from San Francisco. Charles was then a student at Santa Clara University, and family members said he was, unfortunately, not interested in the canning business.[41]

Tom Foon, on the other hand, spent most of his time working. As he buried himself in his work, the Great Depression was on the horizon, and his health was more fragile than he realized. Business friends said his cannery had overproduced in 1929, the last big summer of prosperity before the stock market crash.

But so had just about everybody else in the agriculture business in the Santa Clara Valley.

His death came suddenly in February 1931. "Influential friends throughout the state grieved yesterday over the unexpected death of the wealthy Chinese canner and landowner, who succumbed to pneumonia in O'Connor sanitarium Monday night, He was 42 years old," wrote the *San Jose Mercury Herald* on February 25, 1931.[42] Pneumonia can be deadly in people whose lungs have been weakened by chronic asthma or smoking—both of which applied in the case of Tom Foon. It was a frequently fatal disease then, and there was no good treatment for it until the production of penicillin a decade later.

Thomas Foon was so well known, the story of his untimely death ran as the lead on page three above the fold in the front section of the *San Jose Mercury Herald*. The *San Francisco Examiner* headlined: "The Asparagus King Is Dead."[43] His mother had survived the death of Yen Chew and now had lost her only son. Though the *Mercury Herald*'s story does not carry a byline, the unnamed reporter painted a poignant picture of Foon's grieving mother: "She was seen walking the streets of Alviso yesterday, hiding her sorrow in eyes that scarcely noticed where she was going."[44]

The funeral—delayed until May because Foon died during the Chinese New Year—attracted twenty-five thousand people, including a large delegation of Masons from San Francisco. There were prayers in English and Chinese. Among the pallbearers were the San Jose city manager, the mayor of San Francisco and the president of the California Chamber of Commerce.

Bayside Cannery had grown thanks to Thomas Foon's energy. It did not long survive his passing. He had not prepared anyone to take his place—if anyone could have done that. Perhaps even more critical, his death occurred in the early years of America's Great Depression, when there was no safety

People of many communities took part in memorial services for Thomas Foon Chew—both in San Francisco and San Jose. This funeral procession in San Jose was attended by twenty-five thousand people. *Courtesy of Gloria Hom.*

net for hard economic times. In 1929, unemployment had been just 3 percent. By 1931, the year Tom Foon died, it had risen to 16 percent. By 1933, one in four American workers was out of work, marking the highest unemployment rate in U.S. history. Veterans of World War I marched on Washington. Bread lines clogged the sidewalks of big cities. Warner Bros. ended its sassy comedy *Gold Diggers of 1933* with a moving musical number in a minor key called "Remember My Forgotten Man"—a plaintive tribute to a nation in despair.

Agriculture in the Santa Clara Valley went through a terrible time, as it "tottered on the brink of bankruptcy and collapse," according to the history of the California Prune and Apricot Growers—an organization that became Sunsweet.[45] With so many people out of work, demand for canned goods—and just about everything else—plummeted. After producing 600,000 cases a year and employing thousands of workers, Bayside Cannery went into receivership and closed its doors in 1936.

The City of San Jose has placed four markers in Alviso saluting Thomas Foon Chew and his Bayside Cannery. The city has also named a street in Alviso after this twentieth-century businessman, whose determination helped him find success. *Photo by the author.*

Tom Foon Chew died young but left a legacy as a visionary. To say he was a trailblazer understates all he accomplished.

More important than any fortune he made, the people whose lives he touched never forgot him. An employee named Tony Soares said forty years later: "If he were still alive I'd still be working for him." Bob Lim, a longtime friend, added: "He was good hearted to a fault." And R.R. Mack, who knew him in Alviso, recalled: "Everyone trusted and liked him."[46] He instilled his optimism and drive in his children, and all of them—in spite of the Great Depression and ongoing discrimination— graduated from college. Their children have excelled, too, and their successes and their stories are now woven into the complex fabric of modern California.

He didn't live long enough to see it, but the Chinese Exclusion Acts (by this time a collection of laws) were repealed in 1943, after China became an ally of the United States and joined the fight to defeat the Axis powers in World War II. Six decades later, in January 2011, Edwin Lee became the first son of Chinese immigrants to serve as mayor of San Francisco, the city where Sai Yen Chew first brought his family and began his American life more than a century before. It was an office Lee held until his own untimely death in 2017.

Alviso, once a unique city, became part of the City of San Jose in 1968. In 2003, the city named a street in Alviso after the Bayside entrepreneur, and today, off Zanker Road, you can find Thomas Foon Chew Way, a designation that "brings honor to his descendants."[47]

a few days more. The films were released on Saturdays, and theaters around the country began to expect a new Essanay Western every weekend.

In a world before radio and television—much less all the new media of the twenty-first century—the movies took off so quickly the biggest problem became meeting the demand for them. "By 1910, movies were already a major American industry," said film historian Simon Louvish. "Anything on film made money. The only requirement was that it be reasonably new."[6]

In the course of thinking up weekly plots, Anderson invented a character for himself, Broncho Billy, who was featured in his Westerns, and a fictional town called Snakeville, where many of his comedies took place. Though the faces in his films might change, almost all were written and directed by Anderson, who then starred in many of them. When Spoor visited the company on location in Denver in 1910, he was surprised to see strangers had begun to recognize Anderson in the street. The industry was creating its first stars.[7]

The railroad facilitated location shooting. Since electrical power was still uncertain in many places, the rails meant the Essanay crew could travel with its own generator and with a railroad car fixed up as a mobile film lab, projection room and editing bay. They filled another rail car with portable sets, lights, costumes and props. A flatbed carried Essanay's stagecoach.[8] The company found good filming weather in Colorado and Mexico and then in small towns throughout California, including San Diego, Santa Monica, Pasadena, Santa Barbara, Los Gatos and San Rafael, before finally settling in Niles in 1912.

Author David Kiehn,[9] historian for the Niles Essanay Silent Film Museum, wrote a wonderful book, *Broncho Billy and the Essanay Film Company*, about the years when towns throughout California served as open-air movie sets for Essanay. It was location scout Jess Robbins—later a producer of Charlie Chaplin's films—who first spotted Niles. For one thing, travelers could step on the train in Niles and speed to company headquarters in Chicago. For another, the tiny town was just thirty-five miles south of San Francisco. Best of all, in the early twentieth century, Niles still had wooden sidewalks, modest buildings and unpaved streets tucked into a photogenic setting. "The rolling hills, many canyons and wide-open spaces around Niles were a vast movie backlot ready-made for Anderson's westerns," notes Kiehn.[10]

There was probably no more unlikely place for Charlie Chaplin to turn up than rural Niles. Born in London in 1889, Chaplin was an urban child, the son of improvident music hall performers who separated when he was

Niles Canyon, with its dramatic railroad route, was another great spot for location shooting—one of the many reasons Essanay settled in Niles in 1912. Trains made frequent cameo appearances in Essanay Westerns. This photograph is circa 1870. *Courtesy of History San Jose.*

just two. His father was an alcoholic and his mother a victim of mental illness—in and out of institutions. Charlie, with his older half brother Sydney, spent years shuttling between orphanages, respites with family, schools for indigent children and begging on the streets of South London. To avoid starvation, both he and Sydney went on the stage as children. Film historian Ephraim Katz places Charlie Chaplin in the premiere performance of J.M. Barrie's *Peter Pan* in 1904.[11]

When he was still a teenager, Chaplin earned a spot in the Fred Karno Company, a traveling troupe of English actors who performed comedy stage shows featuring slapstick, acrobatics and pantomime. During two tours of the United States, beginning in 1910 (with Stan Laurel also in the cast), Chaplin became one of Karno's standout performers. The work was an ideal training ground for the pantomime of silent films. And with the business of the movies booming, America was the perfect place for Chaplin to be.

In May 1913, he was performing in Pennsylvania when the Karno road manager received a telegram. "Is there a man named Chaffin in your

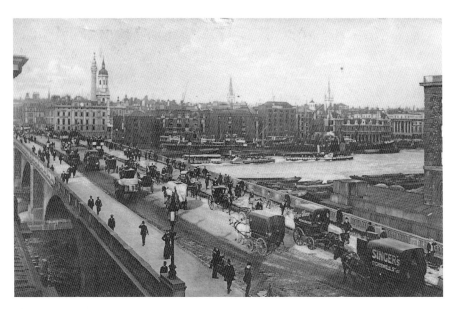

MACK SENNETT COMEDIES

Above: Charlie Chaplin was born in London in 1889, and he and his half brother Sydney sometimes had to perform on street corners in order to earn enough to eat. *Author's collection.*

Left: It was director Mack Sennett of Keystone who first brought the female form in beach attire to the movie business—though the swimsuits on his "Bathing Beauties" were modest by modern standards. Sennett was also the first director to hire Charlie Chaplin. *Author's collection.*

company or something like that stop if so will he communicate with Kessel and Bauman 24 Longacre Building Broadway," the message read.[12] Adam Kessel and Charles O. Bauman were former bookies who had gone into partnership with actor-director Mack Sennett in 1912—reportedly talked into the deal by Sennett to settle his gambling debts—to start a film company called Keystone. With Sennett at the helm, Keystone made its name "as a leading studio in the slapstick comedy field, a genre that evolved in America to new heights of frenzied madness."[13]

Keystone cranked out silent comedy shorts starring Roscoe "Fatty" Arbuckle, Ford Sterling and Mabel Normand, among many others, and made movies that featured bathing beauties, frantic chase scenes and the chaotic Keystone Kops—bumbling, comic lawmen iconic today. Chaplin signed with Keystone in late 1913 for something close to $150 a week, effectively tripling the salary he made onstage.[14]

Keystone made its films in Edendale, California, a streetcar ride north and west of downtown Los Angeles, where several other studios also had operations. Chaplin later recalled it as a place that "could not make up its mind whether to be a humble residential district or a semi-industrial one."[15] During his year there, Chaplin learned the new business, turning out thirty-five knockabout comedies as he developed his distinctive character, the mustachioed Little Tramp called Charlie, a character he invented one day in the wardrobe department at Keystone. "I wanted everything to be a contradiction: the pants baggy, the coat tight, the hat small and the shoes large," he wrote. "I began to know him, and by the time I walked on to the stage he was fully born."[16]

When comedienne and former bathing beauty Mabel Normand was assigned to direct him later that spring, Chaplin told producer Mack Sennett he wanted to direct himself. Sennett agreed, since it was becoming evident Keystone had something special on its hands. After just a handful of films, "Letters came in by the thousands, asking: 'Who is the funny little fellow with the little mustache and the funny walk?'"[17]

As Chaplin's year with Keystone approached its end, Chaplin had grown so popular, fans were beginning to interfere with his location shooting in Los Angeles. "So many spectators surrounded him in a street scene that traffic was blocked for some hours."[18] Hoping to renew his contract, Keystone offered Chaplin what was then a huge raise—$450 a week. But the actor held out for at least $1,000. Mack Sennett, who told Chaplin even *he* didn't make that much money, posted guards around Keystone to keep other producers from approaching him.[19]

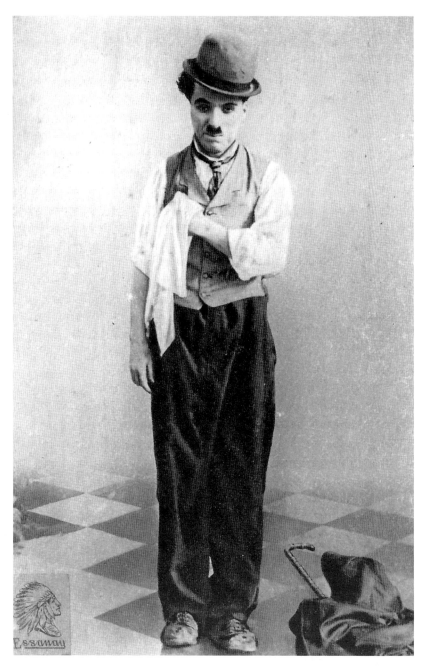

It was at Keystone in Edendale, California, that Charlie Chaplin created the Little Tramp. "I had no idea of the character," he wrote. "But the moment I was dressed, the clothes and the make-up made me feel the person he was." This vintage postcard dates from Chaplin's time at Essanay. *Author's collection.*

Into this volatile opportunity stepped Essanay's perceptive Gilbert M. Anderson. He may have been working out of rural Niles making cowboy movies for hicks in the sticks, but as a partner in Essanay, he was a shrewd businessman. In 1914, he had seen, as audiences had, something unique in Chaplin. In a memorable understatement, Anderson reportedly told his wife: "I find him clever and amusing. I think he could be a great comedian."[20]

From his friend Jess Robbins, Anderson heard of Chaplin's negotiations. He took the train to Los Angeles and, without clearing it with his partner, Spoor, offered Chaplin a one-year contract at $1,250 a week, with a $10,000 signing bonus.[21] In addition, he told the young talent he could write and direct his own stories and take longer to produce them. Chaplin was using his brother Sydney as an agent, and the astonished siblings agreed to the deal. After just a year making movies, Chaplin would be earning ten times his Keystone salary—thirty times his Karno paycheck—and as much money as Woodrow Wilson, the president of the United States.[22]

In December 1914, Chaplin took the train to San Francisco with Anderson, and together they drove south along the edge of San Francisco Bay to Niles. Over the previous two years, Essanay had put down roots there, constructing studio facilities and housing for actors and crew. But half a century later, Chaplin still recalled his disappointment at seeing the studio in the little San Francisco Bay Area town. "When I saw it my heart sank," he later wrote, "for nothing could have been less inspiring."[23] He didn't like the studio facilities—nor did he much care for what he saw of Niles.

Anderson, determined to make the partnership work, convinced his new star to travel with him to the company's operation in Chicago. It was almost Christmas, and Broncho Billy took the Little Tramp home with him. There, Chaplin was surprised to discover Anderson—who lived like a hard-up, road company actor, but was now a millionaire—was married and had a wife and child established in an expensive apartment, complete with a maid and a Christmas tree. "He walked around the tree with a radiant expression on his face," Anderson's wife remembered. "And he kept exclaiming: 'A Christmas tree, a baby, a Christmas tree! It's wonderful.'"[24]

Chaplin made his first Essanay film in Chicago, appropriately titled *His New Job*, about the Little Tramp going to work at a film studio. Though the work went well, Chaplin found the studio not to his liking. Some of the animosity appears to have come when Anderson headed back to Niles after the holidays and Spoor did not show up at all for several weeks. Chaplin's promised bonus was late, and he wasn't getting the attention he seemed to crave from his new employer. He decided the trouble was the atmosphere at

Essanay Chicago. "In the upstairs office the different departments were partitioned like tellers' grilles. It was anything but conducive to creative work. At six o'clock, no matter whether a director was in the middle of a scene or not, the lights were turned off and everybody went home."[25]

Suddenly, Niles, with its sunshine and freedom, began to look better to Chaplin. During the previous year in California, he had grown used to being able to work outdoors in almost all seasons—clearly not possible in Chicago. Unprepared for the difference, he had come east without even an overcoat.[26]

Two weeks into January 1915, Chaplin and Anderson took the train back to Niles. Chaplin continued to disdain the living arrangements there, deciding the successful Anderson—the millionaire cowboy star—was just an odd guy who liked living in bad rooms among rickety furniture. "In his room was an old iron bed with a light-bulb hanging over the head of it," Chaplin remembered. "The bathroom was unspeakable. One had to take a jug and fill it from the bath tap and empty it down the flush to make the toilet work."[27]

But film production in Niles worked very well, and Chaplin's time there changed his work. Set free from the formulas of Keystone and the bean counters at Essanay's Chicago

Gilbert M. Anderson was born Maxwell Henry Aronson in Little Rock, Arkansas. An early producer of cowboy movies, he created the character "Broncho Billy" for himself. He hired Charlie Chaplin to work for his company in 1914. *Author's collection.*

office, Chaplin found his stride. "In his acting Chaplin slowed his pace a bit, depending more on subtle pantomime," wrote biographer Theodore Huff. "The Essanays are well constructed over a more developed plot and show more restraint than his previous efforts."[28]

He had already shown himself to have a visionary view of an artist's compensation. Though new to the industry, he had set a high value on his talent at a time when no one knew if the film business was even going to last. In Niles, Chaplin leapfrogged the salary of Mary Pickford, one of the movies' earliest stars, who had been on the screen since 1909.[29]

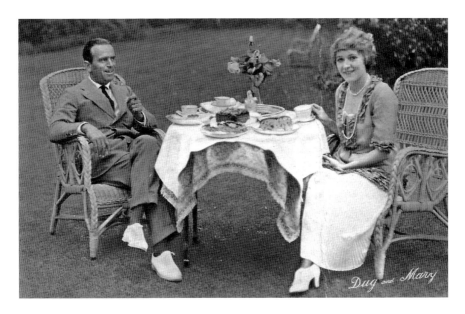

Silent actors Douglas Fairbanks and Mary Pickford were big stars (also married to each other from 1920 to 1936) and became part of Chaplin's life when he returned to Hollywood in 1915. Chaplin joined them as a founder of United Artists in 1919. *Author's collection.*

Essanay quickly discovered Chaplin was worth it. The studio produced two and three times the number of prints of his films and then raised prices and still could not meet demand. "Even with 250 prints in circulation, an astounding six times what Essanay usually required for a typical release, there were still not enough copies to go around."[30] His films were held over for weeks in theaters all around the world, while other movies changed in theaters every few days.

Chaplin's vision added a new factor to the film equation: good quality sold more tickets. "Charlie was now making fewer films with an increasing attention to quality," wrote historian Ephraim Katz.[31] Actor Douglas Fairbanks, who would one day be both a Chaplin friend and business partner, also grew to understand quality could increase revenue. But he didn't enter the movies until 1916.

Chaplin's new contract helped him gain control of his work. In the quieter atmosphere of Niles, he could take three weeks to make a movie, at a time when most comedies took days. "[H]e had already rejected the frantic environment of the studio system," wrote Peter Ackroyd. "He would never work again for another director, and would always write his own parts."[32]

While in Niles, he had still more disruption to pull out from under his battered bowler. After making his first California film for Essanay, *A Night Out*, Chaplin told Anderson he planned to go to San Francisco for the weekend, to celebrate. Since there was pressure to get the new film shipped, cameraman Rollie Totheroh and Anderson decided to edit the movie while Chaplin was gone. But as Totheroh later reported, Chaplin didn't depart and surprised them as they began to work. "We were cutting the first reel and Charlie said, 'Take your hands off that.' At that time we never had a print made; we used to do the cutting on negative. If we scratched it, it was just too bad. So Charlie said, 'And furthermore, I want a print.'"[33]

Take your hands off that. And furthermore, I want a print.

These were extraordinary things for Chaplin, the novice, to have said to two much more experienced filmmakers. But Anderson again deferred to Chaplin. The studio in Niles didn't even have the equipment to make a film print from a negative, but they found what they needed in Chicago and had it shipped out. This enabled the Niles studio to stop editing on its negatives—a very risky practice—and begin assembling what are still today known as rough cuts and workprints. With this, Chaplin established not only

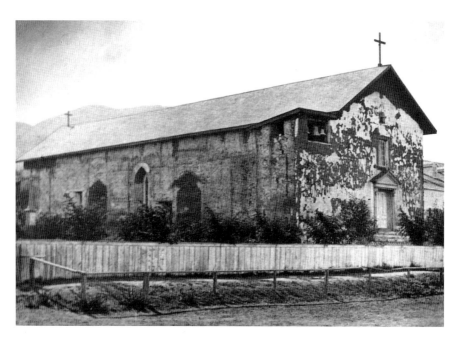

The scenery near Niles included the crumbling remains of Mission San José, just a few miles from the Essanay studios. It was used for location shoots, and at least one Essanay couple married there. *Courtesy of History San José.*

his right to edit his own films but also better film practices for the entire Essanay team.

He also hired his own leading lady in Niles, though she wasn't a local. She was Nevada native Edna Purviance. There are lots of versions of how they met—an ad in a San Francisco paper looking for "the prettiest girl in California" is one. Another says Anderson introduced them. Another supposes that they met at a party. In any case, Chaplin decided the fair-haired Purviance was just what he wanted, adding casting to his portfolio. "She was more than pretty," he remembered, "she was beautiful."[34] By their third film together, *In the Park*, filmed in San Francisco's Golden Gate Park, David Kiehn related: "[E]dna is relaxed and natural for the first time on screen, and Chaplin can't take his eyes of her. Something was going on here."[35] The two were now a couple. "We were serious about each other, and at the back of my mind I had an idea that some day we might marry," said Chaplin.[36]

If this were a fairy tale, Charlie Chaplin and Edna Purviance would have lived happily ever after. But it is a Hollywood story—albeit beginning in Niles—and the couple did not marry. Whatever happened between them, Purviance, one of the few women Chaplin could not quite seem to possess, worked with him longer than any of his co-stars. Long after the two departed Niles and were in relationships with others, Chaplin's chauffeur still picked up Edna every morning for her trip with Charlie to his studio. She starred with Chaplin in some of his best-known work, including *Shoulder Arms* (1918), *The Kid* (1921) and, in a film he made especially for her, *A Woman of Paris* (1923).

In Niles, Chaplin made what film historians call his first masterpiece, *The Tramp*.[37] "[C]haplin finally yielded to the rural atmosphere of Niles," wrote Kiehn. "Begun in Niles Canyon and ending there, production remained in the vicinity throughout its three-week shooting schedule. Here, Chaplin crafted a story with a range of emotions that was unusual for a comedy."[38] In the twenty-minute silent, boy meets girl when he rescues and woos her and then loses her to another love, a poignant conclusion. The Tramp returns to the road walking away, dejected, from the girl and his dreams. With his back to us, he begins to pick up his feet as we see his optimism return. It was yet another Chaplin first. Veteran film reviewer Leslie Halliwell called it "the origin of the into-the-sunset fade out."[39]

And that was it. *The Tramp* was Chaplin's last film in Niles. Working from January 1915 through April of the same year, Chaplin made five films in the San Francisco Bay Area, conceived and edited at Niles. In April, he

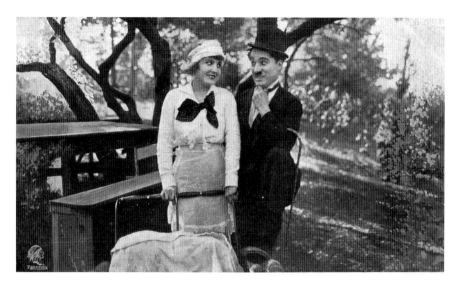

Actress Edna Purviance ("rhymes with reliance") became Chaplin's leading lady in Niles. This vintage postcard shows them in 1915's *In the Park*, filmed in San Francisco's Golden Gate Park. *Author's collection.*

told Anderson he wanted to return to Los Angeles. "I did not feel settled or contented there," wrote Chaplin about Niles,[40] and, as historian Kiehn notes, by 1915, the center of film production had moved to Los Angeles for good. Anderson sent Chaplin south with a crew to look for new Essanay studio space in Hollywood.

When he said goodbye to Niles, Chaplin's star had risen into the stratosphere, but his greatest success was still ahead. In 1916, he signed with Mutual for $10,000 a week. In 1918, he signed with First National for more than $1 million for eight films.[41] In 1919, he joined Douglas Fairbanks, Mary Pickford and D.W. Griffith in founding United Artists. The new company allowed some of the biggest stars of that era to take charge of their own distribution—a revolutionary idea. It was another way in which Chaplin helped to change the industry, of which he had become a leader. Still ahead were Chaplin films still celebrated today, including *The Gold Rush* (1925), *City Lights* (1931), *Modern Times* (1936) and the *Great Dictator* (1940).

The public can be fickle about stars, first elevating them to unreasonable heights—then, seeming to take pleasure in watching them fall. Chaplin, one of the biggest movie stars of all time, had a life that was not without its trouble. He was never an easy man in his private life, in spite of his success. "He does not give you the impression of a happy man," writer Somerset

In 1917, Chaplin built his own studio at 1416 North La Brea Avenue in Los Angeles and designed the studio to look like a charming English village. Owned by various companies since 1953, the studio is now a Los Angeles Historic-Cultural Monument. *Author's collection.*

Maugham said after meeting him in Hollywood.[42] He took many years to move from silent film to sound, and his movies after 1940 faced challenges as Chaplin aged, World War II changed public taste and younger fans found newer idols.

Chaplin also had, as Ephraim Katz discreetly put it, a "penchant for lovely teen-agers." Three of his four wives were under the age of eighteen—the legal age of consent in California—when he began romancing them. His second wife, Lita Grey, was just sixteen when they married. In fact, the only one of his wives who was over eighteen when they met was his third wife, actress Paulette Goddard, and Chaplin probably just made a mistake about her. The former New York showgirl began subtracting years off her age immediately after arriving in Hollywood, variously giving the year of her birth as 1908, 1910, 1911 and 1915. It wasn't until she died that newspaper reports revealed she had been born in 1905.[43]

Chaplin's failed marriages, public income tax problems and a protracted paternity suit filed by a troubled starlet brought him bad publicity in the 1940s and may have hurt him creatively, as well. His dark 1947 film *Monsieur Verdoux*, the story of a serial killer who takes advantage of wealthy widows for their money, did not connect with his audience, and he was booed at the film's premiere.[44] Modern critics continue to find it flawed, with Andrew

Sarris writing in 1970: "Even today it will seem a failure to anyone who has taken half a dozen lessons in film technique."[45]

In the early years of the Cold War, wild stories circulated in the popular press that he was a communist. Chaplin, however, was not an easy man to blacklist: he owned his own studio and, as a partner in United Artists, owned his own system of distribution. But he was vulnerable as a British resident of the United States for more than three decades who had never applied for citizenship. As the Cold War deepened, Chaplin did receive a summons to appear before the House Committee on Un-American Activities. Without prompting, he sent the committee a telegram stating he was not a communist, but added: "I am what you call 'a peace monger.'"[46] He was never called to testify, but the trouble was not over.

In 1952, Chaplin planned a visit overseas for the premiere of his new film *Limelight*. As he sailed from New York, President Harry Truman's attorney general had the Justice Department inform Chaplin on board ship that his reentry would not be automatic and would require an interview. Chaplin had had enough. He vowed never to return to the United States and established a new home for himself and his family in Switzerland. As he later wrote: "In summing up my situation, I would say that in an atmosphere of powerful cliques and invisible government I engendered a nation's antagonism and unfortunately lost the affection of the American public."[47]

But in a plot twist that might have been found in a Chaplin film, public perception changed as the years went by, and young filmmakers rediscovered his work. In 1972, almost sixty years after he first stepped in front of a camera, Chaplin was honored with a special Academy Award, and he returned to America to accept it. Just a few days shy of his eighty-third birthday, his hair white, his body frail, Chaplin stood on the stage in Los Angeles and received a long ovation from a new generation of industry leaders. "This is my renaissance," he told reporters at a news conference. "I'm being born again."[48]

Late in his life, when he was fifty-four and the bride eighteen, he found love with Oona O'Neill, the daughter of playwright Eugene O'Neill, with whom he had a marriage that lasted until his death. They produced eight children together, among them the celebrated actress Geraldine Chaplin. Yet he and Edna Purviance never seemed able to entirely disengage. For the rest of her life, she turned down offers from other studios, and Chaplin, for his part, kept her on his payroll years after he had left the country. "Edna Purviance…remained in my employment up to the day she died," Chaplin revealed.[49] He mentions her in one of the last paragraphs of his

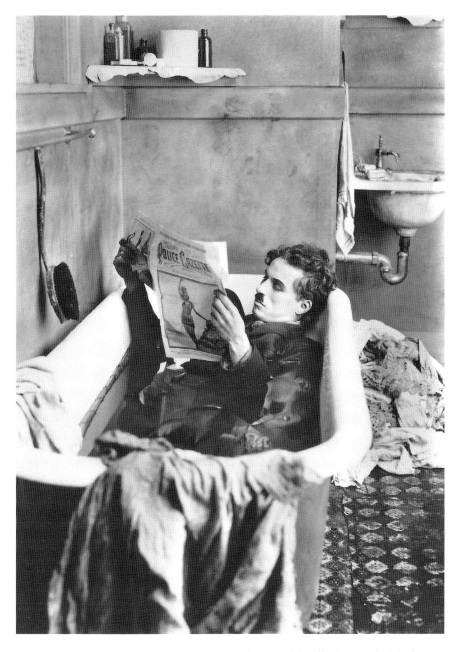

Chaplin made his final film in 1967. Controversial, mercurial, difficult and gifted, he is now considered one of the most important pioneers in film history. This vintage card features a scene from *Payday*, released in 1922. *Author's collection.*

autobiography, quoting a final letter he got from her shortly before her death in 1958: "And so," he wrote, "the world grows young."[50]

Chaplin lived long enough for one more triumph: he was knighted by Queen Elizabeth in 1975. Two years later, on Christmas morning 1977, Sir Charles Spencer Chaplin died at his home in Vevey. He was eighty-eight years old.

Artistic work is assessed and reassessed by each new age. Chaplin's light has never dimmed. Long ago, his vision caught fire in the freedom and inspiration he found at a little studio in Niles, tucked into a rural corner of California on the edge of San Francisco Bay. More than a century after Charlie Chaplin walked the dusty roads there, twirled his cane and hitched his baggy pants, the world is still watching him with wonder in the flickering light.

On the Trail of the California Visionaries

I kept always two books in my pocket, one to read, one to write in.
—*Robert Louis Stevenson*

As a young reporter and aspiring writer, I enjoyed taking tours of the homes of famous authors and once traveled around England with a book called *Discovering English Literary Associations*, by Sidney Blackmore. In it, the author acknowledges why we find the locations associated with these writers so interesting: "It is because this sense of place affects poets and writers that we are interested in seeing where they lived or wrote."[1] I would take his premise a step further and suggest this sense of place impacts all kinds of interesting and talented people and their ideas. When we see where they made history, it gives us insight into their lives and work.

That is the goal of this chapter: to help readers follow the trail of the people whose stories are told in this book. It is not meant to be comprehensive but involves short trips that are relatively easy to take. In the book, I begin with the eighteenth century and work my way into the twentieth century. Since you've just ended in the twentieth century, I organized these tours the other way around. As you take them, you will work your way from Charlie Chaplin back to Lope Inigo.

Armchair travelers need never leave their seats. Others can carry this book as a guide. Those who would emulate Robert Louis Stevenson may bring along their own blank books in which to write as they follow the trail of these innovators, entrepreneurs and California visionaries.

CHARLIE CHAPLIN IN NILES

A great way to learn more about the life of CHARLIE CHAPLIN is to head over to NILES, the village in Alameda County that is now part of the bustling city of Fremont. The minute you turn off busy Mission Boulevard onto Niles Boulevard and head under the old railroad bridge, you will feel yourself entering a place removed from modern-day Silicon Valley. The hills above Niles remain undeveloped—green in winter and golden in the sunshine of summer. Chaplin may have grumbled at Niles's rural atmosphere—but, especially today, that is a great part of its charm.

On your right, as you enter town is the old railway station where Chaplin and BRONCHO BILLY ANDERSON once caught the train. The line through Niles was built for the first transcontinental railroad in 1865 by the Western Pacific Railroad Company, which was later absorbed by the Central Pacific and then the Southern Pacific. Passenger service ceased through Niles in 1984, but in 1988, an organization of volunteers resurrected the line for historic rides, and the Pacific Locomotive Association now operates the NILES CANYON

The Niles Essanay Silent Film Museum was founded by film historian David Kiehn and has brought tourists from all over the world to the Bay Area to pay homage to Charlie Chaplin. *Photo by the author.*

RAILWAY year round. The group has a regular schedule of rides through the canyon on the weekends and many holiday and special event trains. Visit the website of the PACIFIC LOCOMOTIVE ASSOCIATION for details.

Just a few blocks from the station, at 37417 Niles Boulevard, is the NILES ESSANAY SILENT FILM MUSEUM, founded by film historian David Kiehn in 2005. He's the author of *Broncho Billy and the Essanay Film Company*, and he also spent a year restoring the old building that became the museum. The structure's EDISON THEATER was built in 1913, and in the old days, Chaplin, Anderson and the other actors used to stop here from time to time to watch their movies. Today, the museum and theater run a regular schedule of classic films, mostly on the weekends. There are docent-led tours—both of the building and,

on special occasions, of the surrounding neighborhoods, where Chaplin and Anderson once made their movies. Stop in for a show at the Edison Theater, and you may discover museum founder David Kiehn in the projection booth, keeping the evening in focus. In 1957, the Academy of Motion Picture Arts and Sciences recognized Gilbert M. Anderson with a special Oscar®, and the Niles Museum now has his award—if you don't see it on display, be sure to ask about it. For more information, visit the website of the Niles Essanay Silent Film Museum

There are lots of interesting shops and places to eat in Niles, so make time to browse and graze while you are there.

Before you leave the area, you might want to make the short drive—just 4.7 miles—from the village of Niles, directly down Mission Boulevard to old MISSION SAN JOSÉ, the only Spanish mission established on the east side of San Francisco Bay. Founded in 1797 on an ancient Ohlone pathway, this is the fourteenth of the twenty-one Spanish missions in California.

At Mission San José, LOPE INIGO once studied music and sang in the choir. JUANA BRIONES lived here for a time when her husband, Apolinario Miranda, was assigned to the outpost as a soldier. Much of the original adobe church was destroyed in an 1868 earthquake, but the old west wing survived and now houses the museum. The present church was reconstructed over many decades. Broncho Billy Anderson arranged for Essanay actors to put on a show here to help raise money for the work just a few months after Charlie Chaplin left Niles and headed to Hollywood.

Missions throughout California have been working to do a better job of telling the controversial stories of their histories. Take a walk through Mission San José and its museum and let the guide know how well you think this mission has accomplished that goal.

Thomas Foon Chew in Alviso

The remnants of the old BAYSIDE CANNERY in ALVISO still survive. Point your vehicle in Alviso's direction to visit the haunts of Bayside's famous entrepreneur, THOMAS FOON CHEW.

At 1290 Hope Street in Alviso, near the corner of Hope and Elizabeth, you will find what remains of the main Bayside Cannery. It's roofline is reminiscent of the East-meets-West designs used in the Chinatowns of San Francisco and San Jose during the same era. In the 1980s, local

The old Bayside Cannery in the twenty-first century. Several decades ago, students at a local community college painted a mural on the old building as a tribute to Thomas Foon Chew and Alviso history. *Photo by the author.*

community college students painted a distinctive mural on the side of the building depicting Bayside and Alviso history, and the work's faded colors continue to decorate the old structure. Family members point out that by the time Thomas Foon took over the operation, Chinese men were not wearing queues, as depicted in the mural—the custom ended after the 1911 revolution in China. But for historical details, there is a bronze plaque in front of the structure, placed there by the City of San Jose, about Thomas Foon's life and work.

Across the street, at 907 Elizabeth, there is a building that looks like a small house. It was used as the cannery offices for most of Thomas Foon's life. Across from that structure, you will find another plaque with more information on Foon and the care he took to provide housing for his workers on nearby land. Alviso is one of the sunniest spots on San Francisco Bay, so enjoy the weather during your visit under the almost always clear and sunny skies.

Not far from the cannery there is an excellent spot for a view of the bay at the nearby ALVISO MARINA. Continue north on Hope Street, cross

a small bridge over the estuary and stop at 1195 Hope Street—the marina parking lot. At the marina, you can take in the vista of nearby Baylands Park and the Alviso Slough, which now—nearly half a century after people began cleaning up the bay—attract both sealife and birds on their seasonal routes. At the marina, you will find another plaque saluting Thomas Foon. Bring a picnic and your field glasses for a little wildlife observation. Or visit one of the popular restaurants in Alviso for a meal and a chat about local history.

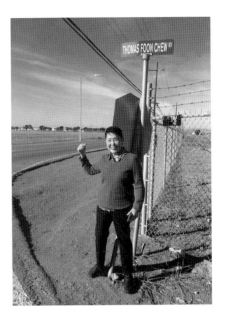

Gloria Hom, the granddaughter of entrepreneur Thomas Foon Chew, enjoys a moment in Alviso on the corner of the street named after her grandfather. He died before she was born, but she remembers her grandmother well. *Photo by the author.*

Don't depart without asking your GPS to take you to the corner of Zanker Road and THOMAS FOON CHEW WAY, on the other side of Alviso from the cannery. At the base of the road sign there is another plaque, the fourth spot in this little community where a bronze marker pays tribute to the man who surmounted so many barriers and turned Bayside Cannery into an enormous success.

As you leave quiet Alviso, you will notice new office buildings for high-tech companies have moved into the borders of Tom Foon's old hometown. They are in great company.

SARAH WINCHESTER IN SAN JOSE AND LOS ALTOS

Following the trail of the life of SARAH WINCHESTER will lead you to the famous WINCHESTER MYSTERY HOUSE. The story told there is colorful. But at least now, after reading Mary Jo Ignoffo's biography *Captive of the Labyrinth* and the chapter on Winchester's life in this book, you have the facts. Even if you come armed with information, you can still suspend your disbelief and enjoy the fun.

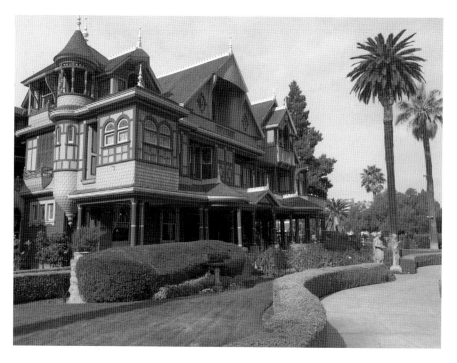

Sarah Winchester's house in the Santa Clara Valley is no longer surrounded by 160 acres, as it was during her lifetime. But it is still an impressive sight—though today it sits next to a freeway. *Photo by the author.*

The house stands at 525 South Winchester Boulevard in SAN JOSE. Though it was once surrounded by Sarah Winchester's 160-acre ranch, it now sits on just 6 acres. On one side, her old house sits next to Interstate 280. On the other, it rests so close to the eponymous Winchester Boulevard the original front gate has been sealed off with industrial fencing. The orchard land that once surrounded the mansion was not retained as part of the setting. Sadly, when it disappeared, the house lost a great deal of its context.

You can preview the tours on the website of the Winchester Mystery House. You can also stop by and ogle the house from the outside if you like. If you do want to take a tour, hours and prices are all listed on the Mystery House site, with special rates for groups and seasonal events scheduled around Halloween and other holidays. Though the house has been in private hands for almost a century, it is a designated California Historical Landmark and is listed in the National Register of Historic Places.

Once you have seen or toured the famous house, loop over onto Interstate 280 and head north for a stop in downtown LOS ALTOS, where you can

continue to follow the Winchester trail. The downtown village sits on land once part of El Sueño, the property Sarah Winchester bought for her sister Isabelle Merriman in 1888. Belle and her husband, Louis Merriman, never really turned the place into a going concern, but they loved the home, which was nestled against the foothills of the Coast Range. The property was eventually developed into the city of Los Altos.

Stroll the shops, and if you feel ready for a break, buy a sandwich and cross over the expressway to Shoup Park, at 400 University Avenue, for a picnic. It is less than a quarter of a mile from the corner of State and Main and is named for the Southern Pacific executive who was the city's first developer. At the park, you can do (almost) as the horses once did—nosh and quench al fresco near Adobe Creek. These days, the creek is usually dry in summer, but in winter, the weather is mild much of the time, and that is when you will see Adobe Creek running swiftly through the park. If you like to walk along creeks—beware. There is almost always a little poison oak near creeks in California.

The J. Gilbert Smith House in Los Altos was built in the same era and in the same region as Sara Winchester's much quirkier mansion. Today, both houses are open to the public. The Smith House is now part of the Los Altos History Museum. *Photo by the author.*

Conclude your day by visiting a house that is a close contemporary of Sarah Winchester's San Jose home and will give you an idea of the kinds of houses non-millionaires were building in the Santa Clara Valley back then. From Shoup Park, drive to 51 South San Antonio Road for a look at the J. GILBERT SMITH HOUSE, a home now part of the LOS ALTOS HISTORY MUSEUM, which sits next to the museum and behind the Los Altos Library. The Smith House was built by orchardist J. Gilbert Smith, with work completed there in 1905. Be sure to check the website of the museum for days and times it is open, then ask at the museum for a docent-led tour of the house.

Smith was a skilled carpenter who built some of the early dormitories at Stanford University and later decided to make his life in the valley growing fruit. He built the house himself and planted ten acres of apricot trees. The remains of his orchard now surround the Los Altos Civic Center, and both the house and the nearby LOS ALTOS CIVIC CENTER ORCHARD are protected as historic landmarks. Gilbert Smith also was an innovator: he designed his covered porch to include an orchard office (to keep work boots out of his house) and created shelves in his pantry that were just the right size to hold a lug (a wooden box) of apricots.

The lives of J. Gilbert Smith and Sarah Winchester are interesting to compare. Both built their own houses in the region in about the same era and designed their homes to suit themselves. Both tended orchards for a profit. Sarah Winchester had the larger fortune and, when she died, left a large endowment to a hospital at Yale to help those who suffered from lung disease, as did her beloved husband. J. Gilbert Smith also prospered, and when he died, he left his house to the City of Los Altos as a way to help future generations learn more about the valley's history. Both lives and both houses express the innovative spirit of California—each in its own way.

ROBERT LOUIS STEVENSON IN MONTEREY

Following the trail of ROBERT LOUIS STEVENSON means a change of scene that will take you out of the Santa Clara Valley to MONTEREY. In 1879, Stevenson was able to make the journey most of the way by rail. You will likely travel to Monterey by car.

Take the route you like best. If you are coming from the Santa Clara Valley, I recommend not going over the Santa Cruz Mountains on Highway 17. It is a beautiful drive, but accidents there can easily turn the road into

a parking lot. I suggest taking Highway 101 south from the San Francisco Peninsula, which will take you through the verge of agricultural California and makes for a pleasant transition between the busy tech corridor of Silicon Valley and the seaside environs of the Monterey Peninsula. During the season, there are lots of produce stands along the way. Stopping for locally grown artichokes, garlic, apricots and strawberries is not mandatory, but it is highly recommended.

Before we arrive in Monterey and begin searching for the footsteps of Stevenson, we must mention the MONTEREY BAY AQUARIUM, 886 Cannery Row, Monterey. Funded by tech pioneer David Packard and his wife, Lucile, it opened in 1984 and quickly became one of the most visited attractions in California. The aquarium entertains and educates visitors about the diversity of the Pacific Ocean ecosystems of the California coast, and if you have a full day or a weekend, please make time to visit the aquarium.

While you are in Monterey, remember LOPE INIGO came here to see state officials as he worked to secure his land grant claim. JUANA BRIONES'S father worked in Monterey during the years just before she was born. SARAH WINCHESTER came here to the old Hotel Del Monte—now Herrmann Hall at the Naval Postgraduate School—and THOMAS FOON CHEW once owned a piece of a fish cannery on old Cannery Row. Monterey is rich in its connection to California visionaries.

When Stevenson came to Monterey in the late summer of 1879 to find his love Fanny Osbourne, the city was a crumbling adobe village. "The town, when I was there," he writes in *The Old Pacific Capital*, "was a place of two or three streets, economically paved with sea-sand….There were no street lights." There were a few wooden sidewalks, he says, which "only added to the dangers of the night, for they were often high above the level of the roadway, and no one could tell where they would be likely to begin or end."[2]

Begin your search for Stevenson at the PACIFIC HOUSE MUSEUM, 20 Custom House Plaza, Monterey. The plaza is off Del Monte Avenue, one of the main thoroughfares along the Monterey Marina and very near Monterey's Fisherman's Wharf. There is good public parking all along the marina.

The museum and the surrounding CUSTOM HOUSE PLAZA are part of the MONTEREY STATE HISTORIC PARK. Park rangers give guided tours of the historic area, with its many adobes, on a regular schedule—three or four times each day—and the walks begin on the steps in front of the Pacific House. It is an easy stroll of about an hour—if you are able. Tickets are not expensive and can be purchased at the museum gift shop.

The old adobe where Robert Louis Stevenson stayed during his months in Monterey is now a California state park. It has a fine Robert Louis Stevenson collection. *Photo by the author.*

The history walk starts with the story of the Ohlone and tells of the arrival of the Spanish, Monterey's days as a whaling station, its life as the capital of Mexican California and more. These are the stories Robert Louis Stevenson would have heard from locals, just a few decades after Monterey had become an American town.

The tour is a great starter, but it will not take you to the ROBERT LOUIS STEVENSON HOUSE. Now a California state park, it can be found at 530 Houston Street, about a ten-minute walk from the Custom House Plaza. Ask at the museum for a map and directions or find it on the route of the MONTEREY STATE HISTORIC PARK CELL PHONE TOUR. The phone tour is free—but you will be using your data. Check the website of the Monterey State Historic Park for more information.

The Robert Louis Stevenson House is a treat. Inside, docents tell about Stevenson's life through one of the best collections in the world of Stevenson memorabilia. You'll see one of his favorite blue velvet jackets and a bookshelf full of his first editions. One of the most touching pieces is the tiny nineteenth-century traveling desk on which he worked. He used it as he traveled the world—a kind of antique version of a laptop.

The Robert Louis Stevenson House is open Saturday afternoons from April through October, but this can change so check times and dates before you visit. Once a year, the home is dressed up for the holidays as part of Monterey's CHRISTMAS IN THE ADOBES, an event that features as many as two dozen of Monterey's landmark buildings lighted and spruced up for two nights each December. Many of these buildings would not have survived if Robert Louis Stevenson had not come to Monterey and advocated for their preservation. You'll need a ticket to attend: ask at the Custom House Store or check the website of the Monterey State Historic Park for information.

In reviewing this tour, the one thing that seems to be missing is romance. Robert Louis Stevenson was a man who traveled more than six thousand

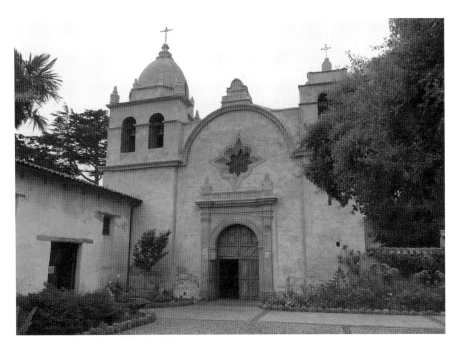

When Stevenson first saw the Carmel Mission, he called it "a ruined mission on a hill," and it sparked his efforts to encourage Californians to preserve their history. *Photo by the author.*

miles to follow the woman he loved. So, if you really want to follow in his footsteps, you might consider making this trip with someone you love.

If you have time, travel the six miles down Highway 1 to Mission San Carlos Borromeo del Río Carmelo, the "ruined mission on a hill" that so intrigued Stevenson, 3080 Rio Road, Carmel. Signs on the highway will direct you. It sits on five acres and is one of the most beautifully restored of the California missions.

They host many weddings at Mission Carmel—but that part of the journey is up to you.

Juana Briones in Los Altos Hills, Palo Alto and Menlo Park

Juana Briones spent most of her life working hard, and she did well as a result. She bought Rancho La Purísima Concepción in about 1844 for just

a few hundred dollars. Acquiring more than four thousand acres of "oak dotted foothills" on one of the key routes between San Francisco and San Jose showed her wisdom.[3] The timing of her purchase was lucky: four years later, the Gold Rush began to inflate land prices. And land as a means to create wealth is a big part of Juana Briones's story.

If you want to see some of the impressive land she owned, drive up El Monte Avenue into Los Altos Hills and pass Foothill College on your right. Look around—all this was hers. When you come to the fork at Moody Road and Elena, take Elena and drive up to Taaffe Road. As you head into the hills, you may notice several large apricot orchards on your left. Those belonged to Silicon Valley technology executive David Packard and his wife, Lucile, who deeded the property to their foundation, which cares for them today. Juana Briones sold this piece of her ranch long ago to valley pioneer Martin Murphy for his daughter Elizabeth and son-in-law William Taaffe. When you reach Taaffe Road, find a safe place to turn around and head back down the hill.

The old Juana Briones House was razed in 2011, but its site at 4155 Old Adobe Road is just a few miles from Taaffe House. Take Foothill Expressway to Arastradero Road, now in Palo Alto, and turn into the hills on Arastradero. From Arastradero, turn on to Old Adobe Road—your GPS can direct you. You won't find her house, of course, but halfway down the street you will find a large marker that salutes her, installed in 2007 by the State of California. "The grant extended two miles south," reads the plaque, "encompassing Foothill College and most of Los Altos Hills." Today, the hills surrounding her old home site include a couple of the nation's priciest residential zip codes—a tribute to Juana Briones and her eye for real estate.

Continue your drive north on Foothill Expressway and Junipero Serra Boulevard through the property of Stanford University to Holy Cross Catholic Cemetery, at 1100 Santa Cruz Avenue, Menlo Park, for a chance to pay tribute to Juana Briones at her final resting place.

As you turn onto Santa Cruz Avenue from Junipero Serra Boulevard and head down the hill toward Menlo, the cemetery will be on your right, and there will be two entrances. Pass the first one (soon to be an exit) and turn right into the second entrance. There, the narrow white gates will lead you into the oldest part of the cemetery. As you enter, you will see a small flag stand to your right. Park there and walk to your left. As you enter the left-hand roadway, look for the Cain family plot, and when you see it, begin to count your strides. I counted eighty strides before I reached the Greer plot, which will be on your right, marked with "Greer" on a low, concrete

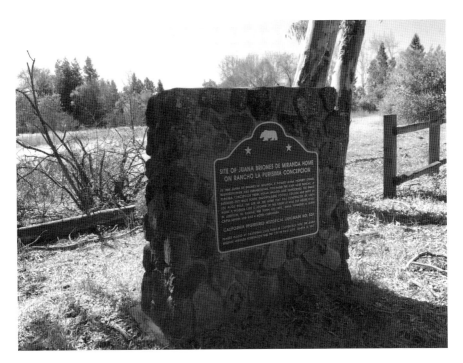

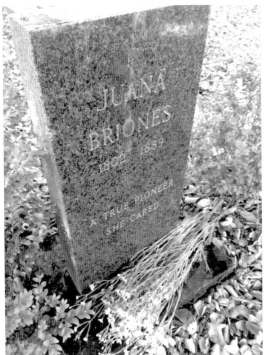

Above: Juana Briones's ranch house sat on what became Old Adobe Road in the foothills of Palo Alto. The State of California placed a historical marker near the home in 2007. The house was razed in 2011. *Photo by the author.*

Left: The marker at Juana Briones's final resting place had long disappeared when historians began to research the Briones story in the twenty-first century. That led to the rediscovery of her grave and a new marker, donated by a California history club. *Photo by the author.*

surround. Just past the marker, turn right onto the grassy path and walk a few steps, and the Juana Briones marker will be on your right. She is buried in Section 49, Plot 11, in case you have trouble finding your way.

The location of her final resting place wasn't known to the public for many years, but it was never really lost—the Holy Cross Catholic Cemetery knew where she was buried all along. The plot was rediscovered by history buffs in the twenty-first century when the legal fight over the razing of her adobe hit the headlines—she was buried under her husband's name, Miranda, which is why it took some time to find her. A California history club put up the money for the new headstone that now marks her grave.

It doesn't seem like much, though, does it? Driving through a little pricey land. Snapping photos of a couple of stone markers. The life of Juana Briones was so much larger than that. This is why we have books. In them we can take more time to read about such a triumphant spirit and rejoice in her many victories.

Lope Inigo at Moffett Field

Lope Inigo and his story go back nearly two and a half centuries. The village in which he was born disappeared during his lifetime. His grave site and the old Inigo Mounds vanished into a field of alfalfa about 1917. The old Mission Santa Clara de Asís, 500 El Camino Real, Santa Clara, was moved and rebuilt several times during the course of the years he worshipped there. The last mission structure he knew burned to the ground in 1926, and the present one is a concrete replica.

Still, there are a couple of very interesting places that help us follow the trail of Lope Inigo. I like one of the places so much, I've saved it for last.

About 1,000 acres of Inigo's 1695.90-acre Rancho Posolmi became Moffett Naval Air Station in the 1930s. And though the base is decommissioned now, the airfield remains a federal field. Its designation, NUQ, is well known to pilots. My father used to fly in and out of NUQ in a Cessna, and today, the airfield is often used by a large Silicon Valley company that specializes in internet searches—you know the one—since that company is leasing many acres of the old base. In addition, the airfield is often used by Air Force One and Air Force Two when presidents and vice presidents of the United States fly into Silicon Valley. Lope Inigo and his ancestral village today often host the highest leaders in the land.

The Moffett Field Historical Society and Museum sits in the shadow of Hangar One on land that was once part of the California rancho of Lope Inigo. *Photo by the author.*

Unless POTUS is visiting, it is easy to get onto the old base: just show your driver's license at any of the gates and tell them you are going to the Moffett Field Historical Society and Museum, 126 Severyns Avenue. (Check the website for information on the days and times the museum is open.) At the gate, ask for directions to the museum or just point your vehicle directly toward one of the largest landmarks in Silicon Valley—Moffett's Hangar One, completed in 1933, one of the largest freestanding structures in the world. It covers eight acres and is a Naval Historical Monument, a State of California Historic Civil Engineering Landmark and listed with the National Trust for Historic Preservation. As a Contributing Property to nearby Shenandoah Plaza—the graceful center of the old base—it is also in the National Register of Historic Places.

The Moffett Museum sits in the shadow of Hangar One. With its bright American flag by the front door and its trim navy anchor on its porch, you can't miss it. In the parking lot next to the museum, there are quite a few vintage military aircraft on display, a sign for history buffs to stop and park.

The museum is set up in sections to take you through the decades of Moffett Field's life. Your walk through this history is aided by volunteer docents, many of them retired military men and women who served at Moffett and at other stations around the globe. They begin by telling you about the Ohlone village that was once on this land and about Lope Inigo and his Rancho Posolmi. Inigo, who survived so much, continues to be honored here.

Once you have completed your tour of the museum, there is one more place you must see. Ask one of the docents for directions to the Ellis Street Gate and the Bayshore/NASA Light Rail Station, just outside the gate. If you are able, it is within easy walking distance of the museum. If you are driving, there is no easy place to park, so tell the guards at the Ellis Gate you want to see the rail station and ask where you can put your car for a few minutes. Let your GPS direct you to the station, just around the corner from the gate.

Once you have found the station, walk to the rail side of the platform. There you will find something special. It is a large marker in the shape of an Ohlone basket and tells the story of Lope Inigo's life. On it is the 1856 photograph of Inigo, taken in San Francisco. This is a man who, by sheer force of will, remained a vibrant part of the world in which he lived, even as the world changed irrevocably around him. Here he remains, in modern California, remembered with a striking memorial at a light-rail station in the heart of the land now called Silicon Valley.

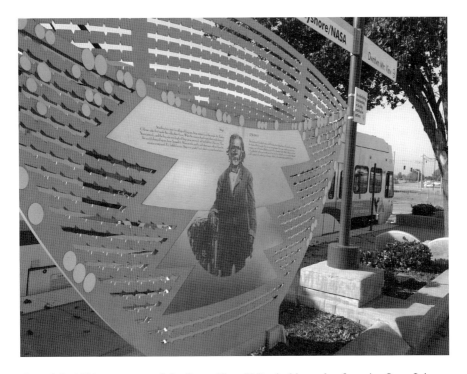

One of the hidden treasures of the Santa Clara Valley is this marker featuring Lope Inigo and his story in an unlikely spot—the platform of the Bayshore/NASA light rail stop at Moffett Field. It pays tribute to a man of accomplishment and dignity. *Photo by the author.*

Not far from this place, Inigo was born into a village of his people. Not far from this place, his body was laid to rest and his spirit set free. What a fitting spot to end this book—in the nexus of the ancient and the modern on a light-rail platform on the site of an Ohlone village on the shores of San Francisco Bay.

§

All of the people whose lives I've written about here faced enormous difficulties. What they had in common was a resolve not to be defeated. As historian Doris Kearns Goodwin said in a recent interview on leadership, "Some people just have a determination to go forward."[4]

Rather than getting stuck in past paradigms, these people sought solutions. As such, they are the progenitors of Silicon Valley's creative thinkers of today.

Acknowledgements

Although I was born and raised in the San Francisco Bay Area, I left the region in my twenties, spending many years covering national news in Washington, D.C. When I returned and began researching California history, I was repeatedly surprised by the number of great and interesting people I kept meeting in books written about the Bay Area by talented authors. It may sound like a cliché to say I stand on their shoulders. But that is exactly what I have done.

The chapter on Lope Inigo would not have been possible without the work of Laurence H. Shoup, Randall K. Milliken and Alan K. Brown. I found their research in the archives of History San Jose, but they have also turned their scholarship into a book, *Lope Inigo of Rancho Posolmi.* Palo Alto historian Jean Farr McDonnell's work *Juana Briones of Nineteenth-Century California* also was a key source.

Mary Jo Ignoffo's biography of Sarah Winchester, *Captive of the Labyrinth*, produced excellent information on Mrs. Winchester. In addition, she helped confirm an incorrect identification of a Winchester family photo.

For thoughtful information on the California missions, I found Edna Kimbro and Julia Costello's *The California Missions: History, Art, and Preservation*, invaluable.

I could not have written the story of Thomas Foon Chew without the help of his granddaughter Dr. Gloria Hom, who gave me a personal tour of the former cannery property in Alviso, shared her family memories with me during our many conversations and loaned me family images. I am indebted

to Debbie Gong-Guy for introducing us. For context, I was aided by Connie Young Yu and her book *Chinatown San Jose*.

I feel lucky to have met Catherine Mills, curator of the library and archives at History San Jose. Many of the images I used here were only available because Ms. Mills unearthed them from the archives collection. She uncovered the Ralph Rambo box of canning labels and noticed two of them carried racist slogans. She also turned up the rare photo that appears to be of the original Winchester house.

I owe my friends Laura Bajuk and Doug Debs a debt for introducing me to Niles, California. On many a weekend sojourn, we have visited the Essanay Museum founded by David Kiehn, with its wonderful Chaplin connection. Kiehn spent seven years researching his book *Broncho Billy and the Essanay Film Company*, and it was a key source on Chaplin's days in Niles.

Thanks go out to the many archives that loaned images for this book, especially the Department of Archives and Special Collections, Santa Clara University, where we found the old photograph of Marcelo. I am especially grateful for the help I received from the Point Reyes National Seashore Archives.

By lucky chance, near the end of my research, I met Steve Staiger. He is historian for the Palo Alto Historical Association Archives and it was with his help, along with that of volunteers Brian George and Jack Parkhouse, that I was able to find several important images for the book.

Many thoughtful people took time out to give me special tours that helped bring the people in this book to life. Thanks to Kathy Wade of Holy Cross Catholic Cemetery in Menlo Park; mission administrator Joan Steele at Mission San Antonio; volunteer Paul Melançon at Mission Santa Inés; and Michael D. Green, interpretive program manager with the Monterey State Historic Park, for his special tour of the Robert Louis Stevenson House.

Finally, I owe Robert Louis Stevenson and my mother incalculable thanks for something that changed my life. Long ago, before I went to school, my mother discovered *A Child's Garden of Verses* by Stevenson and used to read it to me as I sat on her lap in the warm California sunlight of our backyard. When I finally got to kindergarten, I discovered I already knew how to read. Thus, as a toddler, I learned to associate reading with poetry and wonderful stories. What a gift this was to me.

Notes

Introduction

1. In 1979, the City of San Jose added a Spanish diacritical accent to the *e* on San Jose to reflect the city's heritage. Over the years, the accent has come and gone in various citations—it was not used, for example, for the first century and a half after California became a state. For the sake of consistency, I have not used the accent for the city name, the city archives and the original name of the pueblo. On the other hand, Mission San José—which, to add to the confusion, is now in the city limits of Fremont—has always used its diacritical accent and I retained it in this account.

Chapter 1

1. Lope Inigo's name is spelled in various ways, frequently as "Ynigo." Historians Laurence H. Shoup and Randall T. Milliken believe the correct spelling is "Inigo" and that the *Y* is a misreading of the old Spanish cursive version of the letter *I*.
2. Trends have changed over the years about the terminology used to describe the indigenous people of North America. Not all the Indians at Bay Area missions were Ohlone. Many were from other groups that are not always identified. Other terms can be controversial and unwieldy. The National Congress of American Indians is the oldest and largest organization of American Indian and Alaskan Native groups in the United States, and

based on NCAI terminology, I am using the term *Indian* with respect and for ease of reference in this book.

3. Kroeber, *Handbook*, 464.

4. Beebe and Senkewicz, *Lands of Promise and Despair*, 202–3.

5. Kroeber, *Handbook*, 462

6. Shoup, Milliken and Brown, "Inigo of Rancho Posolmi," 13.

7. Margolin, *Ohlone Way*, 1.

8. Shoup, Milliken and Brown, "Inigo of Rancho Posolmi," preface.

9. Margolin, *Ohlone Way*, 157.

10. Shoup, Milliken and Brown, "Inigo of Rancho Posolmi," 30.

11. Margolin, *Ohlone Way*, 158.

12. Shoup, Milliken and Brown, "Inigo of Rancho Posolmi," 44.

13. Ibid., 34.

14. Heizer, *Costanoan Indians*, 81.

15. Shoup, Milliken and Brown, "Inigo of Rancho Posolmi," 58.

16. Ibid., 58–59.

17. Ibid., 65.

18. Ibid., 64.

19. Ibid., 95.

20. Margolin, *Ohlone Way*, 164.

21. Ibid., 4.

22. Ibid., 163.

23. Starrs and Goin, *Field Guide*, 25.

24. De La Pérouse and Margolin, *Life in a California Mission*, 66.

25. Shoup, Milliken and Brown, "Inigo of Rancho Posolmi," 101.

26. Ibid., 103.

27. Ibid., 121.

28. Ibid., 107.

29. Ibid., 109.

30. Ibid., 108.

31. Rambo, *Adventure Valley*, 6.

32. Shoup, Milliken and Brown, "Inigo of Rancho Posolmi," 116.

33. Margolin, *Ohlone Way*, 167.

34. Shoup, Milliken and Brown, "Inigo of Rancho Posolmi," 110.

35. Arbuckle and Rambo, *Santa Clara Valley Ranchos*, 25.

36. De La Pérouse and Margolin, *Life in a California Mission*, 87; Heizer, *Costanoan Indians*, 86; Shoup, Milliken and Brown, "Inigo of Rancho Posolmi," 53; Kroeber, *Handbook*, 465.

37. Shoup, Milliken and Brown, "Inigo of Rancho Posolmi," 118.

38. Ibid., 121.
39. Ibid.
40. Ibid., 123.
41. Ibid., 125.
42. Ibid.
43. Ibid.

Chapter 2

1. McDonnell, *Juana Briones*, 211.
2. Butler, *Old Santa Clara Valley*, 12.
3. Bancroft, *California Pioneer Register*, 70.
4. Bancroft and Bancroft, *Literary Industries*, xiv.
5. A biographical article written by J.N. Bowman in the *Historical Society of Southern California Quarterly*, September 3, 1957, states Briones was born on or about January 9, 1796, at either the Monterey Presidio or Carmel. Later scholarship revealed this child named Juana was an infant who did not survive. McDonnell's more recent scholarship uncovered the birth year of 1802. See Gullard and Lund, *History of Palo Alto*, 41.
6. Voss, "Archaeology of El Presidio," chapter 9.
7. Vladimir Guerrero, *Anza Trail*, 142–44; McDonnell, *Juana Briones*, 48.
8. The elk were almost wiped out during the Gold Rush and, by 1872, were reduced to just a few breeding pairs in the state. Conservation efforts have brought them back from about 2,500 in the 1970s to an estimated 13,000 today, including "four herds on the outskirts of the Bay Area," according to reporter Tom Stienstra in his article "Wildlife Victory Crowned by 13,000 Elk," *San Francisco Chronicle*, December 10, 2017.
9. McDonnell, *Juana Briones*, 27–29.
10. Ibid., 30, 37.
11. Couchman, *Sunsweet Story*, 6.
12. McDonnell, *Juana Briones*, 29.
13. Steele, interview with the author.
14. Beebe and Senkewicz, *Lands of Promise and Despair*, 292.
15. Ibid., 290.
16. McDonnell, *Juana Briones*, 41.
17. Shoup, Milliken and Brown, "Inigo of Rancho Posolmi," 57.
18. Fava, *Los Altos Hills*, 32.
19. Ibid., 34.
20. Kimbro and Costello, *California Missions*, 190.

21. Voss, "Archaeology of El Presidio," chapter 9.

22. Arbuckle and Rambo, *Santa Clara Valley Ranchos*, 19.

23. Voss, "Archaeology of El Presidio," chapter 9.

24. McDonnell, *Juana Briones*, 64, 132.

25. Gullard and Lund, *History of Palo Alto*, 41; McDonnell, *Juana Briones*, 107.

26. McDonnell, *Juana Briones*, 67.

27. Ibid., 86.

28. Voss, "Archaeology of El Presidio," chapter 9.

29. Bancroft, *California Pioneer Register*, 249.

30. Hoover, Rensch and Rensch, *Historic Spots*, 331.

31. Kimbro and Costello, *California Missions*, 190.

32. Voss, "Archaeology of El Presidio," chapter 9.

33. McDonnell, *Juana Briones*, 104.

34. Shoup, Milliken and Brown, "Inigo of Rancho Posolmi," 110.

35. McDonnell, *Juana Briones*, 156–58; Fava, *Los Altos Hills*, 37.

36. Hoover, Rensch and Rensch, *Historic Spots*, 331.

37. Ibid., 331.

38. Ibid., 332; McDonnell, *Juana Briones*, 210.

Chapter 3

1. McCrum, *Wodehouse*, 190–91.

2. Lapierre, *Fanny Stevenson*, 4.

3. Harman, *Myself and the Other Fellow*, 126.

4. Lapierre, *Fanny Stevenson*, 163.

5. Harman, *Myself and the Other Fellow*, 123–24.

6. Ibid., 156.

7. Murphy, *Across America*, 8.

8. Ibid., 14.

9. Harman, *Myself and the Other Fellow*, 186.

10. Bland, *Stevenson's California*, 13.

11. Ambrose, *Nothing Like It*, 53.

12. Ibid., 17.

13. Murphy, *Across America*, 40.

14. Ambrose, *Nothing Like it*, 45.

15. Murphy, *Across America*, 131.

16. Stevenson, *Travels and Essays*, 148.

17. Lapierre, *Fanny Stevenson*, 265.

18. Harman, *Myself and the Other Fellow*, 200.
19. Ibid., 178–79.
20. Kimbro and Costello, *California Missions*, 44.
21. Ibid., 64.
22. Chapman, *California Apricots*, 56.
23. Kimbro and Costello, *California Missions*, 51.
24. Ibid., 51
25. Bland, *Stevenson's California*, 17.
26. Kimbro and Costello, *California Missions*, 51.
27. Ibid., 178–79.
28. Kiehn, *Broncho Billy*, 223.
29. Melançon, interview with the author.

Chapter 4

1. Woelfl, *Sarah Pardee Winchester*, 10.
2. Trevelyan, *Winchester*, 117.
3. Ignoffo, *Captive of the Labyrinth*, 6.
4. Trevelyan, *Winchester*, 117.
5. Rambo, *Lady of Mystery*, 14.
6. Ignoffo, *Captive of the Labyrinth*, 20.
7. Trevelyan, *Winchester*, 12.
8. Williamson, *Winchester*, 457; Trevelyan, *Winchester*, 33, 53.
9. Ignoffo, *Captive of the Labyrinth*, 60.
10. Rambo, *Lady of Mystery*, 11.
11. Ignoffo, *Captive of the Labyrinth*, 69.
12. Trevelyan, *Winchester*, 120.
13. Butler, *Old Santa Clara Valley*, 147.
14. Rambo, *Lady of Mystery*, 8.
15. Ignoffo, *Captive of the Labyrinth*, 90.
16. Rambo, *Lady of Mystery*, 5.
17. Williamson, *Winchester*, 213.
18. Sawyer, *History of Santa Clara County*, 139.
19. Ignoffo, *Captive of the Labyrinth*, 92.
20. Ignoffo, email interview with the author, May 4, 2017.
21. Chapman, "How the Mysterious Sarah Winchester Played a Role in Los Altos' Founding."
22. Trevelyan, *Winchester*, 135.

23. Ignoffo, *Captive of the Labyrinth*, 111.
24. Trevelyan, *Winchester*, 142.
25. Butler, *Old Santa Clara Valley*, 148.
26. Ignoffo, *Captive of the Labyrinth*, 156.

Chapter 5

1. Young Yu, *Chinatown San Jose*, 3.
2. Winchester, *Crack in the Edge*, 345.
3. Smithsonian Institution, "I Want the Wide American Earth."
4. Winchester, *Crack in the Edge*, 345.
5. Young Yu, *Chinatown San Jose*, 4.
6. Ambrose, *Nothing Like It*, 21.
7. Gilbert Olsen and Richard Floyd, "The San Jose Railroad," in *Chinese Argonauts*, edited by Gloria Sun Hom, 139.
8. Jacobson, *Passing Farms, Enduring Values*, 155.
9. Young Yu, *Chinatown San Jose*, 1.
10. McDonnell, *Juana Briones*, 179.
11. Couchman, *Sunsweet Story*, 4.
12. James Wright, "Thomas Foon Chew—Founder of the Bayside Cannery," in *Chinese Argonauts*, 21.
13. U.S. State Department, "Chinese Immigration and the Chinese Exclusion Acts," https://history.state.gov/milestones/1866-1898/chinese-immigration.
14. Richard Nielson, "The New Almaden Quicksilver Mine 1850–1900," in *Chinese Argonauts*, 200.
15. Young Yu, *Chinatown San Jose*, 17.
16. Yung and Chinese Historical Society of America, *San Francisco's Chinatown*, 33.
17. Minnick, *Never a Burnt Bridge*, 39.
18. Wright, "Thomas Foon Chew," *Argonauts*, 33.
19. *San Jose Mercury Herald*, February 25, 1931.
20. Hom, interview with the author.
21. Minnick, *Never a Burnt Bridge*, 39.
22. Hom, *Chinese Argonauts*, preface.
23. *Mercury Herald*, February 25, 1931.
24. For ease of communication, this account uses Bayside to identify the Chew family business.

25. Burrill and Rogers, *Alviso San Jose*, 97.
26. Wright, "Thomas Foon Chew," 23.
27. Ibid., 23.
28. Hom, interview.
29. Young Yu, *Chinatown San Jose*, 103.
30. *Mercury Herald*, February 25, 1931.
31. Burrill and Rogers, *Alviso San Jose*, 96.
32. Wright, "Thomas Foon Chew," 38.
33. Ibid., 29.
34. Ibid., 24.
35. Ibid., 33–34.
36. Tsu, *Garden of the World*, 78.
37. Ibid., 79.
38. *Mercury Herald*, February 25, 1931.
39. Ibid.
40. Hom, interview.
41. Ibid.
42. *Mercury Herald*, February 25, 1931.
43. Wright, "Thomas Foon Chew," 35.
44. *Mercury Herald*, February 25, 1931.
45. Couchman, *Sunsweet Story*, 89.
46. Wright, "Thomas Foon Chew," 39.
47. Burrill and Rogers, *Alviso San Jose*, 98.

Chapter 6

1. Muybridge's photographs are still so iconic today a series of them, "Man Riding Galloping Horse" (1884), was used as the basis of a silk scarf designed by Caty Latham-Audibert for the equally iconic French house of Hermès. The scarf is called "Séquences" and was issued in 1984. Coleno, *Hermès Scarf: History & Mystique*, 92–93.
2. Ball, *Inventor and the Tycoon*, 316.
3. Schickel, *D.W. Griffith*, 640; Starr, *California*, xxii. Griffith's first California film was called *The Newlyweds*.
4. Ackroyd, *Charlie Chaplin*, 273.
5. Kiehn, *Broncho Billy*, 83.
6. Louvish, *Chaplin*, 51.
7. Kiehn, *Broncho Billy*, 35.

8. Ibid., 41–43.
9. David Kiehn made news in 2010 when he challenged the 1905 date of a piece of silent film titled *A Trip Down Market Street*, which featured views of San Francisco photographed by the Miles brothers. Using weather information and vehicle registration plates, Kiehn proved the film was shot shortly before the 1906 San Francisco earthquake, and his discovery was featured on the CBS program *60 Minutes*. More recently, he has digitally restored a newly discovered silent film, also by the Miles brothers, that features similar San Francisco scenes just after the earthquake.
10. Kiehn, *Broncho Billy*, 89.
11. Katz, *Film Encyclopedia*.
12. Chaplin, *Autobiography*, 138.
13. Katz, *Film Encyclopedia*.
14. There is some debate about Chaplin's original Keystone weekly salary, which may have been either $125 or $150. Most sources agree he was making $175 a week by the end of 1914. Louvish, *Chaplin*, 51.
15. Chaplin, *Autobiography*, 141.
16. Ibid., 145.
17. Fowler, *Father Goose*, 240.
18. Ackroyd, *Chaplin*, 73
19. Huff, *Charlie Chaplin*, 46.
20. Kiehn, *Broncho Billy*, 185.
21. Ibid., 183.
22. University of Michigan, "Presidential and Vice Presidential Salaries," Government Documents Center, accessed at https://web.archive.org/web/20110606213444/http://www.lib.umich.edu/node/11736.
23. Chaplin, *Autobiography*, 161.
24. Kiehn, *Broncho Billy*, 185.
25. Chaplin, *Autobiography*, 165.
26. Kiehn, *Broncho Billy*, 185.
27. Chaplin, *Autobiography*, 168.
28. Huff, *Chaplin*, 47.
29. Pickford, *Sunshine and Shadow*, 163.
30. Kiehn, *Broncho Billy*, 207.
31. Katz, *Film Encyclopedia*.
32. Ackroyd, *Chaplin*, 75.
33. Kiehn, *Broncho Billy*, 197.
34. Chaplin, *Autobiography*, 169.
35. Kiehn, *Broncho Billy*, 203.

36. Chaplin, *Autobiography*, 203.
37. Katz, *Film Encyclopedia*.
38. Kiehn, *Broncho Billy*, 203.
39. Halliwell, *Film Guide, The Tramp* (1915).
40. Chaplin, *Autobiography*, 170.
41. Katz, *Film Encyclopedia*.
42. Chaplin, *Autobiography*, 266.
43. Katz, *Film Encyclopedia*.
44. Huff, *Chaplin*, 281–84.
45. Halliwell, *Film Guide, Monsieur Verdoux* (1947).
46. Chaplin, *Autobiography*, 439.
47. Ibid., 458.
48. Katz, *Film Encyclopedia*.
49. Chaplin, *Autobiography*, 475.
50. Ibid., 477.

Chapter 7

1. Blackmore, *Discovering English Literary Associations*, 4.
2. Stevenson, *Travels and Essays*, 158.
3. Arbuckle and Rambo, *Santa Clara County Ranchos*, 19.
4. Italie, "A Tribute to 'Leadership'."

Selected Bibliography

Ackroyd, Peter. *Charlie Chaplin*. New York: Nan A. Talese, 2014.

Ambrose, Stephen E. *Nothing Like It in the World: The Men Who Built the Transcontinental Railroad 1863–1869*. New York: Simon & Schuster, 2000.

Arbuckle, Clyde, and Ralph Rambo. *Santa Clara County Ranchos*. San Jose, CA: Rosicrucian Press, 1968.

Ball, Edward. *The Inventor and the Tycoon: The Murderer Eadweard Muybridge, the Entrepreneur Leland Stanford, and the Birth of Motion Pictures*. New York: Anchor Books, 2013.

Bancroft, Hubert Howe. *California Pioneer Register and Index, 1542–1848*. Baltimore, MD: Regional Publishing Company, 1964.

Bancroft, Kim, and Hubert Howe Bancroft. *Literary Industries: Chasing a Vanishing West*. Berkeley, CA: Heyday, 2013.

Bean, John Lowell. *The Ohlone Past and Present: Native Americans of the San Francisco Bay Region*. Menlo Park, CA: Ballena Press, 1994.

Beebe, Rose Marie, and Robert M. Senkewicz. *Lands of Promise and Despair: Chronicles of Early California, 1535–1846*. Berkeley, CA: Heyday, 2001.

Blackmore, Sidney. *Discovering English Literary Associations*. Aylesbury, UK: Shire Publications, 1973.

Bland, Henry Meade. *Stevenson's California*. San Jose, CA: Pacific Short Story Club, 1924.

Bowman, J.N. "Juana Briones de Miranda." *Historical Society of Southern California Quarterly* 39, no. 3. (September 1957): 227–41. http://scq.ucpress.edu/content/39/3/227.full.pdf+html.

Burrill, Robert, and Lynn Rogers. *Alviso San Jose*. Charleston, SC: Arcadia Publishing, 2006.

Butler, Phyllis Filiberti. *Old Santa Clara Valley: A Guide to Historic Buildings from Palo Alto to Gilroy*. San Carlos, CA: Wide World Publishing/Tetra, 1975 and 1991.

Chandler, Robert J. Comments on Jeanne Farr McDonnell, University of Arizona Press. http://www.uapress.arizona.edu/Books/bid1986.htm.

Chaplin, Charles. *My Autobiography*. New York: Penguin, 1992. First published 1964.

Chapman, Robin. *California Apricots: The Lost Orchards of Silicon Valley*. Charleston, SC: The History Press, 2013.

———. "How the Mysterious Sarah Winchester Played a Role in Los Altos' Founding." *Los Altos Town Crier*, May 31, 2017.

Coleno, Nadine. *The Hermès Scarf: History & Mystique*. London: Thames & Hudson, 2010.

Connors, Ann, Alice Marshall and Seonaid L. McArthur. *Los Altos Reminiscences*. Cupertino: California History Center, DeAnza College, 1973.

Couchman, Robert. *The Sunsweet Story*. San Jose, CA: Sunsweet Growers, 1967.

Daly, Kathryn. *Historias: The Spanish Heritage of Santa Clara Valley*. Cupertino: California History Center, 1976.

De La Pérouse, Jean François, and Malcolm Margolin. *Life in a California Mission: Monterey in 1786*. Berkeley, CA: Heyday, 1989.

Fava, Florence M. *Los Altos Hills: The Colorful Story*. Woodside, CA: Gilbert Richards Publications, 1976.

Fowler, Gene. *Father Goose: The Story of Mack Sennett*. New York: Covici Friede Publishers, 1934.

Gong-Guy, Lillian, Gerrye Wong and the Chinese Historical and Cultural Project. *Chinese in San Jose and the Santa Clara Valley*. Charleston, SC: Arcadia Publishing, 2007.

Guerrero, Vladimir. *The Anza Trail and the Settling of California*. Berkeley, CA: Heyday, 2006.

Gullard, Pamela, and Nancy Lund. *History of Palo Alto: The Early Years*. San Francisco, CA: Scottwall Associates, 1989.

Halliwell, Leslie. *Halliwell's Film Guide*. New York: HarperPerennial, 1995.

Hardwick, Michael R. *La Purísima Concepción: The Enduring History of a California Mission*. Charleston, SC: The History Press, 2015.

Harman, Claire. *Myself and the Other Fellow: A Life of Robert Louis Stevenson*. New York: HarperCollins Publishers, 2005.

Heizer, Robert F. *The Costanoan Indians*. Cupertino: California History Center, 1974.

Hom, Gloria Sun, ed. *Chinese Argonauts: An Anthology of the Chinese Contributions to the Historical Development of Santa Clara County*. Los Altos Hills: California History Center, 1971.

————. Interviews with the author. October 2017–March 2018.

Hoover, Mildred Brooke, Hero Eugene Rensch and Ethel Grace Rensch. *Historic Spots in California*. Stanford, CA: Stanford University Press, 1948 and 1990 editions.

Huff, Theodore. *Charlie Chaplin*. New York: Henry Schuman, 1951.

Ignoffo, Mary Jo. *Captive of the Labyrinth: Sarah L. Winchester Heiress to the Rifle Fortune*. Columbia, MO: University of Missouri Press, 2010.

————. Electronic correspondence with the author, May 2017–February 2018.

Italie, Hillel. "A Tribute to 'Leadership.'" *San Francisco Chronicle*, February 16, 2018.

Jacobson, Yvonne. *Passing Farms, Enduring Values: California's Santa Clara Valley*. Cupertino: California History Center Foundation, 2001.

Katz, Ephraim. *The Film Encyclopedia: The Most Comprehensive Encyclopedia of World Cinema in a Single Volume*. New York: HarperPerennial, 1994.

Kiehn, David. *Broncho Billy and the Essanay Film Company*. Berkeley, CA: Farwell Books, 2003.

Kimbro, Edna E., and Julia G. Costello. *The California Missions: History, Art and Preservation*. Los Angeles, CA: Getty Conservation Institute, 2009.

Kroeber, Alfred Louis. *Handbook of the Indians of California*. New York: Dover Publications, 1976. First published in 1925.

La Pérouse, Jan François, and Malcolm Margolin. *Life in a California Mission: Monterey in 1786*. Berkeley, CA: Heyday, 1989.

Lapierre, Alexandra. *Fanny Stevenson: A Romance of Destiny*. New York: Carroll & Graf, 1995.

Louvish, Simon. *Chaplin: The Tramp's Odyssey*. New York: Thomas Dunne Books, 2009.

Margolin, Malcolm. *The Ohlone Way: Indian Life in the San Francisco–Monterey Bay Area*. Berkeley, CA: Heyday, 1978.

McCrum, Robert. *Wodehouse: A Life*. New York: W.W. Norton, 2004.

McCullough, David. *Mornings on Horseback: The Story of an Extraordinary Family, a Vanished Way of Life, and the Unique Child Who Became Theodore Roosevelt*. New York: Simon and Schuster, 1981.

McDonald, Don. *Early Los Altos and Los Altos Hills*. Charleston, SC: Arcadia Publishing, 2010.

McDonnell, Jeanne Farr. *Juana Briones of Nineteenth-Century California*. Tucson: University of Arizona Press, 2008.

McLynn, Frank. *Robert Louis Stevenson: A Biography*. New York: Random House, 1993.

Melançon, Paul. Interview with the author, October 4, 2017. Mission Santa Inés, Solvang, California.

Minnick, Sylvia Sun. *Never a Burnt Bridge*. Stockton, CA: SMC Press, 2013.

Murphy, Jim. *Across America on an Emigrant Train*. New York: Clarion Books, 1993.

Parsons, Mary Elizabeth. *The Wild Flowers of California*. Berkeley, CA: James J. Gillick & Company, 1955. First published in 1887.

Pickford, Mary. *Sunshine and Shadow: The Autobiography of Mary Pickford*. London: William Heinemann, 1956.

Rambo, Ralph. *Adventure Valley: Stories of Santa Clara Valley Pioneers*. San Jose, CA: Rosicrucian Press, 1970.

———. *Lady of Mystery: Sarah Winchester*. San Jose, CA: Rosicrucian Press, 1967.

San Jose Mercury Herald. "Funeral Rites for Thos. Chew to Be Delayed." February 25, 1931, 3.

Sawyer, Eugene T. *History of Santa Clara County, California*. Los Angeles, CA: Historic Record Company, 1922.

Schickel, Richard. *D.W. Griffith: An American Life*. New York: Simon and Schuster, 1984.

Shoup, Laurence H., Randall T. Milliken and Alan K. Brown. "Inigo of Rancho Posolmi: The Life and Times of a Mission Indian and His Land." Unpublished report for Tasman Corridor Archaeological Project, Santa Clara County Transportation Agency. Archaeological/Historical Consultants for Woodward-Clyde Consultants, Oakland, California. May 1995. History San Jose Archives.

Smithsonian Institution Traveling Exhibition Service. "I Want the Wide American Earth: An Asian Pacific American Story." Los Altos History Museum, October 2017.

Starn, Orin. *Ishi's Brain: In Search of America's Last "Wild" Indian*. New York: W.W. Norton, 2004.

Starr, Kevin. *California: A History*. New York: Random House, 2005.

Starrs, Paul F., and Peter Goin. *Field Guide to California Agriculture*. Berkeley: University of California Press, 2010.

Steele, Joan Kathryn. Interview with the author, October 3, 2017. Mission San Antonio, California.

Stevenson, Robert Louis. *The Amateur Emigrant*. New York: Carroll & Graf Publishers, 2002. First published in 1896.

———. *The Travels and Essays of Robert Louis Stevenson: Vol. XV: The Amateur Emigrant, Across the Plains, & The Silverado Squatters*. New York: Charles Scribner's Sons, 1911.

Stienstra, Tom. "Wildlife Victory Crowned by 13,000 Elk." *San Francisco Chronicle*, December 10, 2017.

Trevelyan, Laura. *The Winchester: The Gun that Built an American Dynasty*. New Haven, CT: Yale University Press, 2016.

Tsu, Cecilia M. *Garden of the World: Asian Immigrants and the Making of Agriculture in California's Santa Clara Valley*. New York: Oxford University Press, 2013.

United States of America, Department of State, Office of the Historian. "Chinese Immigration and the Chinese Exclusions Acts." https://history.state.gov/milestones/1866-1898/chinese-immigration.

University of Michigan. "Presidential and Vice Presidential Salaries." Government Documents Center. https://web.archive.org/web/20110606213444/http://www.lib.umich.edu/node/11736.

Voss, Barbara. "The Archaeology of El Presidio de San Francisco: Culture Contact, Gender, and Ethnicity in a Spanish-colonial Military Community." PhD diss., University of California, Berkeley, 2002. Stanford University Research at the Presidio: Tennessee Hollow Watershed Archeological Project, https://web.stanford.edu/group/presidio/juana.html.

Williamson, Harold F. *Winchester: The Gun that Won the West*. New York: A.S. Barnes and Company, 1952.

Winchester, Simon. *A Crack in the Edge of the World: America and the Great California Earthquake of 1906*. New York: HarperCollins, 2005.

Woelfl, Genevieve. *Sarah Pardee Winchester, A Driven Woman—Her Compelling Story*. Irvine, CA: Redwood Publishers, 1986.

Woodworth, Edwin B. *The Birth of a Town: A Historic Resource Manuscript*. Los Altos, CA: History House Books, 1988.

Yu, Connie Young. *Chinatown San Jose, USA*. San Jose, CA: History San Jose, 2001.

Yung, Judy, and the Chinese Historical Society of America. *San Francisco's Chinatown*. Charleston, SC: Arcadia Publishing, 2006.

INDEX

A

Alvarado, Juan Bautista
 on Inigo struggle with Father José
 Viader 22
Alviso
 plaques and street name honoring
 Thomas Foon Chew 129
 visiting today 129
Anderson, Gilbert M. "Broncho
 Billy" 111, 112, 117, 129
Anza, Juan Bautista de
 expedition to California 39

B

Bancroft, Hubert Howe
 mentions Juana Briones in his
 Pioneer Register 38
 notes on Apolinario Miranda 48

Bayshore/NASA Light Rail Station
 large marker honors Inigo 142
Bayside Cannery. *See* Thomas Foon
 Chew and Sai Yen Chew
 finding the building in Alviso
 today 129
 founded and named 98
 growth of 103
 variations in spelling of name 98
Big Basin Redwoods State Park 9
Briones, Marcos
 father of Juana Briones, ethnic
 origins of 41
 his father marries indigenous
 woman after death of his
 mother 41
 learns cattle business at Mission
 San Antonio 43
 marries Ysadora Tapia, Juana
 Briones's mother 41

Briones, Vincent
 paternal grandfather of Juana
 Briones, arrives in California
 with Gaspar de Portolá 39
Briones y Tapia de Miranda, Juana
 de la
 annual fiestas 52
 as early orchardist 51
 born near Santa Cruz, California
 43
 builds adobe in San Francisco 47
 buys ranch from José Gorgonio
 49
 death of 53
 death of husband 50
 death of mother 44
 early work as an entrepreneur 45
 family moves to San Francisco 44
 husband and spouse abuse 47
 loss of four children to disease 47
 marriage to Apolinario Miranda,
 1820 45
 mother and husband's mother
 come to California with Anza
 expedition 39
 moves to Mayfield 1884 53
 plaque at her former adobe in
 Palo Alto hills 138
 testimony 1844 requesting
 separation 48
 visiting her final resting place 138
Brown, Alan K.
 historian for Lope Inigo VTA
 research paper 17
Brown, Charles
 may have supplied redwood to
 Juana Briones for her house
 1844-45 49
 sailor helped by Juana Briones 47

C

California missions
 beauty of 68
 deterioration of following 1833
 66
 reassessment of 70
 secularization of 25
 uses of missions after
 secularization 66
Catala, Father Magín
 baptizes Juana Briones's daughter
 Isidora 47
 construction projects at Mission
 Santa Clara 20
Chaplin, Charlie (Sir Charles
 Spencer Chaplin)
 death in Switzerland 126
 early life 112
 following his trail in modern-day
 Niles 128
 goes to work for Fred Karno 113
 goes to work for Keystone 115
 growing fame at Keystone 115
 informed in 1952 his re-entry
 visa renewal would not be
 automatic 124
 insists on film print and doing his
 own editing 120
 invents Little Tramp character 115
 issues during Cold War period 123
 issues with women 123
 knighted 126
 makes first Essanay film in
 Chicago 117
 makes first masterpiece at Niles 121
 marries Oona O'Neill 124
 returns to Los Angeles 1915 122
 returns to Niles 1915 118

returns to the U.S. for award 1972 124

romantic relationship with Edna Purviance 121

sees Niles and is not impressed 117

Chew, Lee Gum Ching
marriage to Thomas Foon Chew 98

Chew, Sai Yen
impact of San Francisco earthquake on 93

moves business to Alviso in 1906 98

mystery of his immigration 96

owned Precita Canning in San Francisco 97

Chew, Thomas Foon
builds housing for workers and arranges for transportation 100

education of 98

eldest son's wedding 105

enters his father's business 1906 98

expands to Mayfield, Isleton and Monterey 100

health issues of and their relation to stress 103

his death 105

his mother's grief 105

impact of Great Depression on his business 106

innovations of 100

legacy 107

marriage 98

nickname 101

on his kindness to workers 103

worked even when Alviso plant flooded 100

Chinese Exclusion Act
passed in 1882 96

repealed in 1943 107

Chinese in California
anti-Chinese laws attempted 96

arrive during Gold Rush 93

Chinese Exclusion Act passed in 1882 96

worked for Juana Briones on her ranch 94

work in agriculture 94

work on Central Pacific Railroad 94

Clark, Walter
developer in early Los Altos 87

Costanoan
as an early name for Ohlone 16

D

De Back, William
helps Tom Foon Chew devise method to can green asparagas 101

Durán, Father Narciso
priest at Mission San José 23

E

Edison Theater
and Niles Essanay Silent Film Museum 128

Edison, Thomas Alva
Gilbert Anderson works for on *The Great Train Robbery* 111

perfects invention of moving pictures 110

El Sueño
 Winchester-Merriman ranch in
 what became Los Altos 84
Essanay
 founding of 111
 movie company which bring
 Charlie Chaplin to Niles 111
Estrada, Francisco
 owner of Mexican land grant
 Pastoría de las Borregas 28

F

Fairbanks, Douglas
 joins Chaplin in founding of
 United Artists 122
Font, Pedro
 encounter with Ohlone in the
 eighteenth century 18
 writes about the Ohlone in Palo
 Alto 16
Foothill College
 location on Juana Briones's rancho
 138

G

Giguam
 baptized 20
 stepmother of Lope Inigo 19
Goddard, Paulette
 marriage to Chaplin and date of
 birth controversy 123
Gorgonio, José
 granted Rancho La Purísima
 Concepción 49
 regarding his rancho 137

sells ranch to Juana Briones 49
works at Mission Santa Clara 47
Yokuts burn his ranch home 49
Grey, Lita
 age of when marries Chaplin 123
Griffith, David Wark
 joins Chaplin, Pickford and
 Fairbanks in founding of
 United Artists 122
 shoots first movie in California
 110

H

Heizer, Robert
 on California's coastal Indians 15
Hom, Dr. Gloria Sun
 comment on Chinese immigration
 during Exclusion Act 97
 on her grandfather's refusal to be
 segreated 103

I

Ignoffo, Mary Jo
 discovery of letter showing Sarah
 Winchester did stop work on
 her house from time to time 87
 on Sarah Winchester's dispute
 with the railroad 87
 on the power of ghost stories 74
Inigo, Lope
 applies for land grant 25
 at Mountain View May Day
 celebration 34
 baptized at Mission Santa Clara 19
 becomes alcalde 21

born in the Santa Clara Valley 17
death of and burial at ranch 35
death of first wife, Viviana 25
death of second wife 34
falls ill 1864 34
fight with Marcelo 29
land grant authorized 28
location of Inigo Mounds 16
marries Maria Viviana 21
marries second wife 29
photograph taken in 1856 34
possible help given to Father
 Gregory Mengarini on
 Ohlone vocabulary 34
Spanish call his village San
 Bernardino 19
takes respites with his family to his
 ancestral village 23
visiting locations related to him
 in modern day Silicon Valley
 140

K

Kiehn, David
 as author of history of Essanay
 112
 on Chaplin and Edna Purviance
 121
 on Chaplin's first masterpiece and
 Niles influence on it 121
Kroeber, Alfred Louis 16

L

Lasuén, Father Fermín 23
Leib, Samuel Franklin
 works for Sarah Winchester 81
Lincoln, Abraham
 support for transcontinental
 railroad 61
Llanada Villa
 growing size of 87
 name Sarah Winchester gives to
 her ranch near San Jose 81
 Sarah Winchester's innovations at 88
Lyman, Chester Smith
 surveys Briones ranch 49

M

Marcelo
 fight with Inigo 29
 first recorded encounter with
 Inigo 22
 granted Rancho Ulistác 28
Margolin, Malcolm
 author of book on Ohlone 20
 on why Ohlone came to the
 missions 20
Marriott, Frederick
 husband of Sara Winchester's
 niece Marion 84
Maugham, W. Somerset
 on Chaplin 123
McDonnell, Jeanne Farr
 biographer of Juana Briones 37
 on Juana Briones as an
 entrepreneur 47
 on Juana Briones as early orchard
 grower 51

Merriman, Isabelle C. "Belle"
lives at ranch purchased for her by
Sarah Winchester 84
moves to Palo Alto 87
sister of Sarah, joins her in
California 84
Merriman, Louis
brother-in-law of Sarah
Winchester 84
Milliken, Randall T.
historian for Lope Inigo VTA
research paper 17
Miranda, Apolinario
death of 50
ethnic origins of 45
jailed for abuse of his wife, Juana
Briones 48
marriage to Juana Briones 45
Mission Dolores
lack of priest after secularization 48
where Juana Briones and family
worshipped 44
Mission San Antonio de Padua
Juana Briones's parents there and
siblings born 41
Mission San Carlos Borromeo del
Río Carmelo
preservation begins 1882 68
visiting it today 137
when first seen by Robert Louis
Stevenson 66
Mission San José
proximity to Niles Canyon and
Essanay Museum and visiting
129
where Inigo trained in music 23
Mission Santa Clara
baptismal records on Lope Inigo
and family 18

blankets of 23
construction projects under Father
Magín de Catala 20
epidemics 25
Father Mercado appeals to
governor on Inigo's behalf
28
Father Serra lays cornerstone of
new sanctuary 1781 19
Juana Briones's daughter baptized
47
Juana Briones's father stationed
there 43
Juana Briones testifies there on her
husband's abuse 48
modern conrete sanctuary 140
more than one thousand Indians
baptized by 1793 20
priests identify Tamien as Ohlone
name for the people of the
Santa Clara Valley 16
size of its land grant 25
Mission Santa Cruz
murder of Father Andrés
Quintana 43
Ohlone born there says his father
recalled seeing first fruit trees
arrive from New Spain 20
Mission Santa Inés
Chumash warrior painting 70
treasures of 70
Moffett Field
built on old Inigo ranch, 1930s 35
Moffett Historical Society and
Museum
visiting today 142
Murphy, Martin, Sr.
buys land for daughter Elizabeth
Taaffe from Juana Briones 51

Murrieta, Joaquin
 mythic connection to Juana
 Briones 52
Muybridge, Eadweard
 and invention of moving pictures
 109

N

Niles
 1915 size of 110
 benefits of for shooting Westerns
 112
 proximity to Silicon Valley and
 Stanford University 110
 visiting today 128
Niles Canyon Railway 128
Niles Essanay Silent Film Museum
 128
Normand, Mable
 early Keystone star assigned to
 direct Chaplin 115

O

Ohlone
 as name used to replace
 Costanoan 16
 dancing traditions of 23
 decline in population along with
 other California Indians 29
 dialects and languages 16
orchards
 cultivated by Sarah Winchester 84
 Inigo plants at his rancho 28
 planted by Juana Briones 51
 seedlings arrive from Mexico 20

P

Pacific Locomotive Association
 and Niles Canyon Railway 128
Palo Alto
 connection to Juana Briones 49
Pickford, Mary
 highest-paid film star until
 Chaplin 118
 joins Chaplin in founding of
 United Artists 122
Porter, Edwin S.
 director of *The Great Train Robbery*
 111
Purviance, Edna
 Chaplin writes of in his
 autobiography 124
 hired by Chaplin 121
 lifelong work for Chaplin 121

Q

Quintana, Father Andrés
 murder of at Mission Santa Cruz 43

R

Rambo, Edward "Ned"
 shows Sarah Winchester the Santa
 Clara Valley 81
 works for Winchester 75
Rambo, Ralph
 as donor of two important fruit
 labels to History San Jose
 102
 nephew of Edward Rambo, who
 worked for Winchester 75

recalls arrival of Sarah Winchester in Santa Clara Valley 81

remembers Sarah Winchester 75

tells story of Inigo's fight with Marcelo 29

Rancho La Purísima Concepción

granted to José Gorgonio 49

purchased by Juana Briones 1844 49

Rancho Posolmi

granted to Lope Inigo 1844 29

possible origins of the name 30

Rancho Ulistác

granted to Marcelo 28

Robbins, Jess

as location scout, finds Niles 112

tells Gilbert Anderson of Chaplin's Keystone negotiations 117

Ronsom

sister of Inigo 20

S

Samis

baptized 20

father of Lope Inigo 18

San Francisco earthquake and fire

impact on Chinese immigration 91

Serra, Father Junípero

founding of Mission Carmel 66

lays new cornerstone at Mission Santa Clara 19

Shew, William

his photograph used on VTA plaque honoring Inigo 142

photographs Inigo 1856 34

Shoup, Laurence H.

historian for Lope Inigo VTA research paper 17

Shoup, Paul

railroad executive and Los Altos developer 87

Simoneau, Jules 65

Sitjar, Father Buenaventura

works on dictionary of indigenous languages 41

Smith, J. Gilbert

leaves house to Los Altos on his death 134

orchardist's house open to the public 134

Spoor, George Kirke

doesn't welcome Chaplin in Chicago 117

one of Essanay's founders 111

Sprague, Homer Baxter

brother-in-law of Sarah Winchester, appointed president of Mills College 81

Sprague, Sarah Antoinette "Nettie"

sister of Sarah Winchester comes to California with husband Homer 81

Stanford, Leland

involvement in the invention of moving pictures 109

Steele, Joan

modern administrator at Mission San Antonio 41

Stevenson, Frances "Fanny" Van de Grift Osbourne

agrees to marry Stevenson 70

feelings about Stevenson's bad teeth 64

husband Sam a founder of San Francisco's Bohemian Club 56

leaves France for Oakland 58

meets Robert Louis Stevenson 56

not sure about leaving her husband 64

Stevenson biographer comment on 56

Stevenson, Robert Louis

appearance when he arrives in Monterey 63

arrives in San Francisco 63

attends mass at Mission Carmel 68

death in Samoa 71

family of 56

following his trail in Monterey today 134

has teeth pulled to please Fanny 70

ill health 58

law studies 57

meets Fanny Osbourne in France 56

notes beauty of America 63

proposes preservation of California's missions 68

sees Carmel Mission for the first time 65

success in literature after marrying Fanny 70

takes job at small Monterey paper 66

takes steamer to America 59

wins Fanny Osbourne's hand 70

T

Tapia de Briones, Ysadora

death of 44

mother of Juana Briones, marriage to Marcos Briones 41

Temnem

mother of Lope Inigo 18

Thomes, William

American recalls Juana Briones in San Francisco 47

Totheroh, Rollie

as Essanay cameraman 120

Transcontinental Railroad

Chinese contributions to 94

dangers of 62

facilitates movie location shooting 112

history of 61

Robert Louis Stevenson travels on 62

Sarah Winchester travels on 78

V

Valley Transportation Authority connection to Lope Inigo story 16

Villa de Branciforte

Santa Cruz settlement where Juana Briones is born 43

W

Walkinshaw, Robert

buys land from Lope Inigo 30

daughters maintain Lope Inigo grave 35

death of in Scotland 34

Winchester Mystery House
 size of 74
 visiting today 131
Winchester, Oliver Fisher 76
 founder of Winchester Repeating
 Arms Company 77
Winchester repeating rifle
 many uses of in American West
 77
Winchester, Sarah
 born in Connecticut 75
 buys ranch in Santa Clara Valley
 81
 daughter Annie's birth and brief
 life 78
 death of her husband 80
 earthquake damage to her house
 near San Jose 90
 fights railroad over proposed
 line through Winchester-
 Merriman ranch 87
 following her trail in modern-day
 Silicon Valley 132
 ghost stories about 74
 her death 90
 kindness to others 87
 loving marriage of 78
 marries William 77
 purchases property in Atherton,
 Burlingame and Palo Alto 84
 raises apricots and prunes at her
 ranch near San Jose 84
 travels to California for the first
 time 78
Winchester, William Wirt
 death of 80
 marries Sarah 77

transfers from his father's shirt
 company to Winchester
 Repeating Arms Company
 77

Y

Yerba Buena
 original name of San Francisco
 44
Yu, Connie Young
 on Thomas Foon's innovations
 100
 on what drove Chinese to come to
 California 91

ABOUT THE AUTHOR

Robin Chapman is a longtime journalist who is a native of the Santa Clara Valley. She earned her master's degree in journalism from the University of California–Los Angeles before setting out on a long career in television news. She worked at KRON-TV in San Francisco and several other stations in the West before heading to Washington, D.C., where she covered the White House, Congress and the U.S. Supreme Court in addition to other local, national and international stories for the ABC-TV station. Seeing history in the making in the nation's capital stirred her interest in America's stories, and her interest grew as she continued her work as a journalist. In 2009, she returned to California and published her first book about her home state: *California Apricots: The Lost Orchards of Silicon Valley* (The History Press, 2013). She now works as a contributor to a number of publications, writes a history column for a Silicon Valley weekly and serves on the board of the Los Altos History Museum. This is her fifth book, her second about California.